When They Were Young

When They Were Young

A PHOTOGRAPHIC RETROSPECTIVE OF CHILDHOOD

FROM THE LIBRARY OF CONGRESS

ROBERT COLES

PREFACE BY JAMES H. BILLINGTON, THE LIBRARIAN OF CONGRESS

KALES PRESS in association with THE LIBRARY OF CONGRESS

Library of Congress Editorial Team:
W. Ralph Eubanks, Director of Publishing
Amy Pastan, Picture Selection and Text Editor
Alex Hovan, Editorial Assistant

Kales Press Editorial Team:
Kenneth Kales, Publisher
Victoria Austin-Smith, Editorial Assistant
Jamie Wynne, Editorial Assistant

Design: Linda McKnight Design

Library of Congress Cataloging-in-Publication Data

Coles, Robert.
When they were young: a photographic retrospective of childhood from
the Library of Congress/Robert Coles; preface by James H. Billington.—1st ed. p. cm.
"Published in conjunction with the Library of Congress exhibition"—T.p. verso.
Includes index.
ISBN 0-9670076-5-8 (Hardcover: alk. paper)
1. Photography, Artistic—Exhibitions.
2. Photography of children—Exhibitions.
3. Photograph collections—Washington(D.C.)—Exhibitions.
4. Library of Congress—Photograph collection—Exhibitions.
I. Library of Congress. II. Title.

TR645.W182 L533 2002
779'.25'074753—dc21

2002007177

Printed by Amilcare Pizzi, Milan, Italy

LIBRARY OF CONGRESS
www.loc.gov

KALES PRESS, INC
www.kalespress.com

Preface

THE WORLD OF CHILDHOOD, when viewed through photographs, evokes a range of feelings, from joy to nostalgia. Images of children at play, or just being themselves, create a longing for the carefree world of children and serve as a reminder that children live in a world separate from adults. But photography can connect us to that separate world, for photographs of children offer a captivating and expansive view of the ways children humanize the adult world.

The Library of Congress is pleased to join with Robert Coles and Kales Press in publishing this unique photographic retrospective of childhood, which includes works from many of the great photographers whose work is preserved in our collections: Lewis Hine, Toni Frissell, Edward Curtis, Dorothea Lange, Jack Delano, and Marion Post Wolcott, to name only a few. Each of these photographers captures the playfulness and burden of childhood in a unique way. Whether it is Toni Frissell capturing a boy playing with his shadow or Lewis Hine's image of a boy working in a factory, each image reveals a component of the experience of childhood and invites us to see the surrounding world through the eyes of a child.

Preserving the richness of the human experience and making it accessible to all is one of the Library's primary missions. On the pages of this book you will see images of children from the collections of the Library of Congress reaching from the dawn of photography up through the twentieth century. Because these are archival images, historical items frozen in time, they are often viewed with a sense of detachment. However, in this photographic retrospective, the images beg us to respond to them on

an emotional as well as historical level. Our hearts as well as our minds are engaged when we view these images of children through the ages.

This collection of photographs of children celebrates one component of our diverse collections, which now number some 125 million items. The richness illustrated in this book can be further explored through our other publications, or by means of the Internet at http://www.loc.gov. We hope that many of you can come in person to the Library of Congress to share in the legacy of our photographic and other collections, in both our permanent exhibitions and our public reading rooms. The beautifully textured reflection that Robert Coles has provided for the pictures in the pages that follow is a model of how we can all be enlightened and touched by the photographic record of the Library of Congress and the renewing magic that children bring to the adult world.

JAMES H. BILLINGTON
THE LIBRARIAN OF CONGRESS

of this past century a certain pediatrician worked hard to diagnose the ailments of the many children he saw day to day, often in homes rather than through office visits. "The Doc," as many of the parents of those boys and girls called him, also happened to write poems, stories, and essays. He was forever trying to put into words what his eyes and ears offered his thinking mind, his reproaching heart—hence the following earnestly stated comment: "If we would only let them be so, children are often ready to be our teachers. When we become thoughtful about things, we want to know about life's purpose. Waiting to show us what it means to keep going, what we need to do to stay on top of things, are our sons and daughters, or the kids next door or across the street or around the block. They are going from one step to another, trying to meet this business of living as best they can. They hold on, that's what they do: one breath and then another; one step and then another; one piece of food (if they're lucky) and then another, until the stomach signals *okay, that's enough*, or the world (a parent, a school teacher, a nurse in the hospital, a baby-sitter) says the same."

The writing doctor paused, trying to catch his own breath, take his own kind of contemplative step into the terrain of childhood, as it gets lived—and then another assertive leap: "Sometimes I'll be sitting here in my office [at 9 Ridge Road, Rutherford, New Jersey, during the summer of 1955] and I'll go back in my head—reverse the day's direction, you could say. I think of pictures all the time, even while I read words. I

remember what I've seen through pictures. I'll remember seeing a kid smiling or frowning, a kid trying to be agreeable, or wanting out— of my office, or a school that's driving the poor little one up the wall due to a not very good teacher, or some trouble in the playground outside the classroom. I'll remember seeing a kid looking aimlessly out the window or up to the ceiling, and right away I'll be wondering what's going on in his or her mind? Where would the little fellow or lass rather be? The eyes of the children get my imagination going, stir me to try to fill in the blanks, to figure out who is really sitting there on my examining table."

Another pause, and then a smile followed by a thoroughly unnecessary apology: "I'm just wandering all over the place, like so many children want to [do], not because they're 'lost,' or 'confused' or 'uncertain' (the words their elders use), but because they're on the lookout. That's the word I often use to myself when I think of children. They're on the lookout for something to do, someplace to be, something that will give the day some action. If you're doing something then by golly, you're alive! We grown-ups, I often think to myself, tend to forget how much it means to a kid that there's this to go get done, and that. One achievement after another! Momentum matters—why not?"

Although my career took me elsewhere in the decades that followed, the above came to my mind loud and clear as I looked at the pictures that make up this book's photographic retrospective. Here are children from all over the world, who have been spotted by those with cameras, then caught for the rest of us to consider and contem-

plate through photographs. The images now form part of an extraordinary archive at America's Library of Congress. In a sense, then, what follows are moments of childhood seen by those at hand to take serious note of certain infants, certain growing boys and girls. In the documentary tradition they gave the immediately visible future permanence, made possible by the camera's summoned, held attention. What follows, too, is an editorial effort to pick and choose among many thousands of available pictures in the hope of arriving at a selection that is affectingly telling. The children present us with possibilities and postures, stirring us to thought and deed and prodding us, mind and heart, to respond.

"Childhood knows the human heart"

— EDGAR ALLAN POE (*Tamerlane* 1827)

WE START WITH AN INFANT'S TWO BARE FEET, the toes of one a bit extended. Photographer Suzanne Szasz' glimpse of *The Newborn* in 1955 is a reminder, perhaps, that we who have mastered standing were once thoroughly in need of the outstretched arms of others. All is hope and promise, before we learn to stand, then strut. We move to mothers with their young children: an unknown photographer, about 1858, wants us to attend *Gertrude M. Hubbard and Her Baby Daughter Mabel*. Nearly half a century later, Edward Steichen offers us *Mother and Child—Sunlight*. In both instances maternal attentiveness and affection figure poignantly. A baby girl is being solidly held in a mother's ample embrace, and a child shows eager interest in a mother who responds. The young one's outstretched left arm and hand tells a story of both need and trust, the sun's light shining on human connection as it grows—love tendered, received, returned, and here, memorialized.

SUZANNE SZASZ. *The Newborn.* Gelatin silver print. 1955.

12

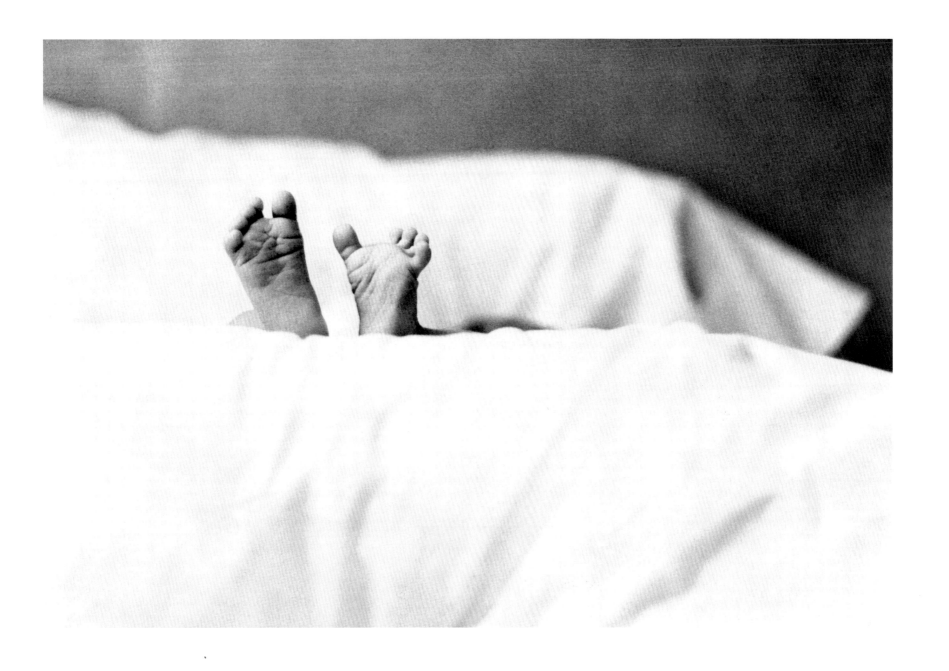

PHOTOGRAPHER UNKNOWN. *Gertrude M. Hubbard and Her Baby Daughter Mabel.* Sixth-plate daguerreotype, cut down, hand-colored. Circa 1858.

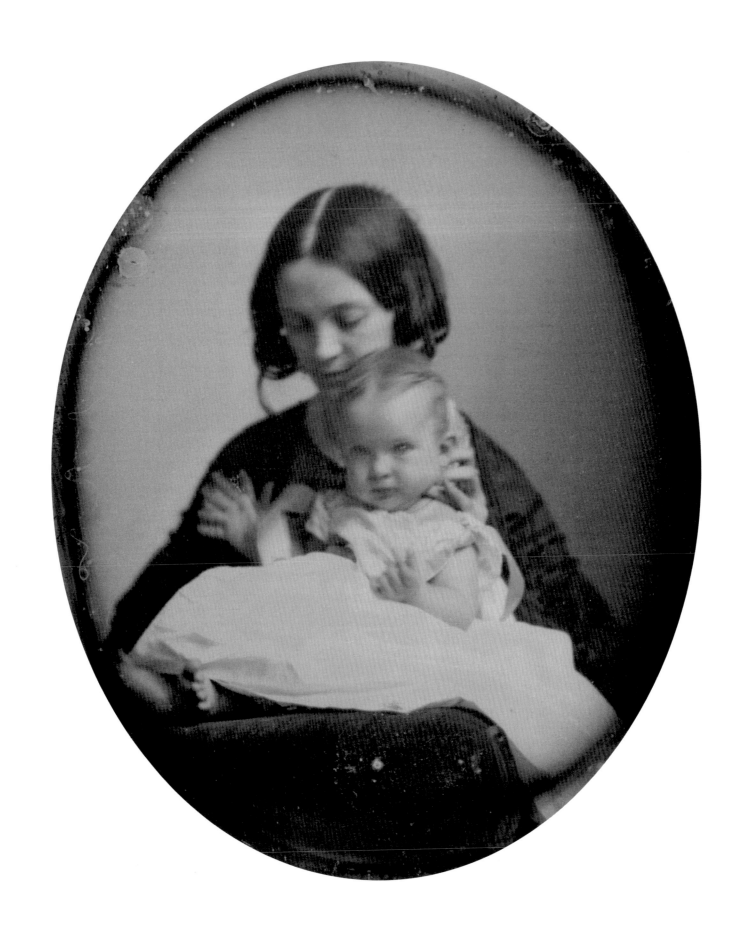

EDWARD STEICHEN. *Mother and Child—Sunlight.* Photogravure. 1906.

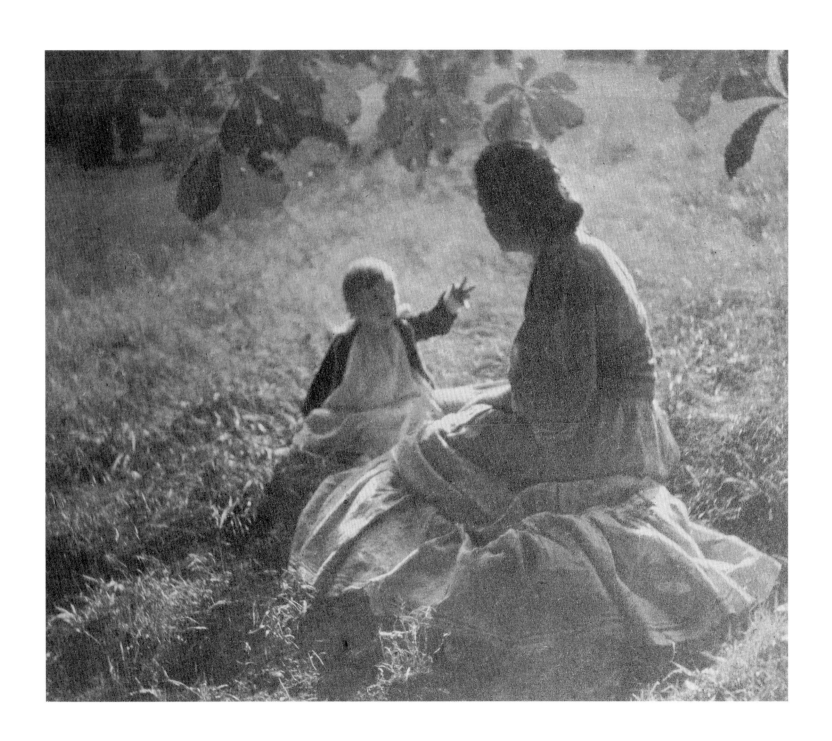

NOW WE MOVE TO CHILDREN A BIT OLDER: they are sitting or standing to some extent on their own. Russell Lee's *Sharecropper's Children* hail from New Madrid County, Missouri. The year is 1940, and one of the two girls holds a doll on her lap and looks straight at us, while her sister looks down pensively. There are no shoes for the younger girl but the older sister luckily wears protection for her feet, even as a partially seen adult beside the children is shoeless, his or her frayed dungarees a testimony all its own to the constant labor of agricultural work. These girls possess a vulnerable dignity that calls forth our concern, while the sad scene to their rear invites our curiosity, offering a view of a working life's particulars.

RUSSELL LEE. *Sharecropper's Children.* Gelatin silver print. New Madrid County, Missouri, 1940.

18

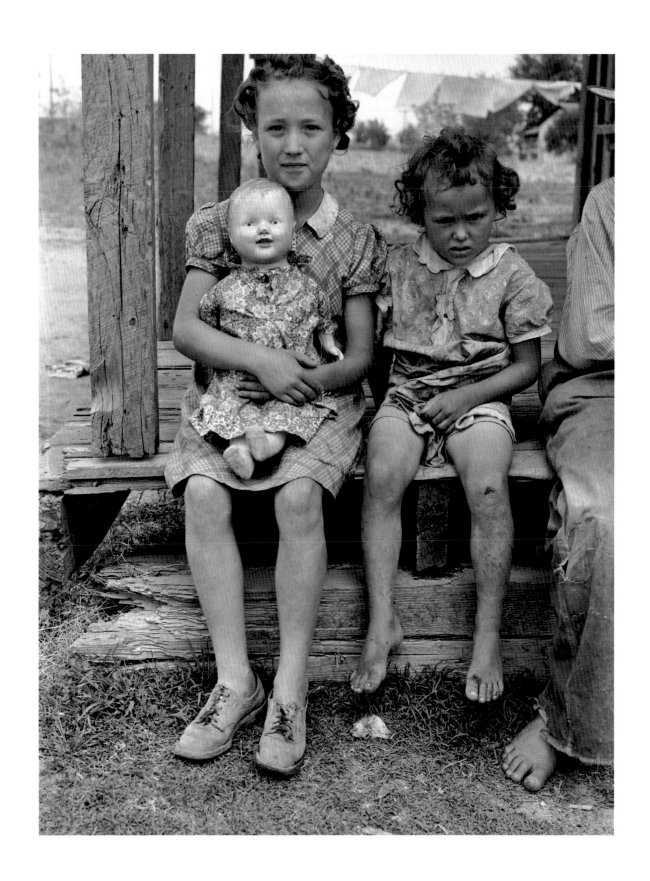

Her Charges. We are in Tarente, Italy. The year is 1918, and the children are given full, immediate presentation, with a sidewalk and street their platform and only the very bottom of a home's door in sight. Center stage, a smiling girl holds a smaller lass, who wears a babushka. To their rear, another girl, her head similarly covered with a nicely folded scarf, gazes to our left, as does a smaller girl. An altogether different scene unfolds at right. Three boys stare forward, their bodies a virtual visual slump. We see children maintain their resilience in a world governed by adults. F. Holland Day's African American girl, her white collar (an adornment or an enclosure?) such a contrast to her skin; Mathilde Weil's girl, busily embroidering, the girls in both images alive in the first decades of the twentieth century; and then Theodor Jung's boys from Jackson, Ohio—quite sturdy, two even smiling, no matter the tough times that visited their country in the mid 1930s.

LEWIS WICKES HINE. *A "Little Mother" and Her Charges.* Gelatin silver print. Tarente, Italy, 1918.

20

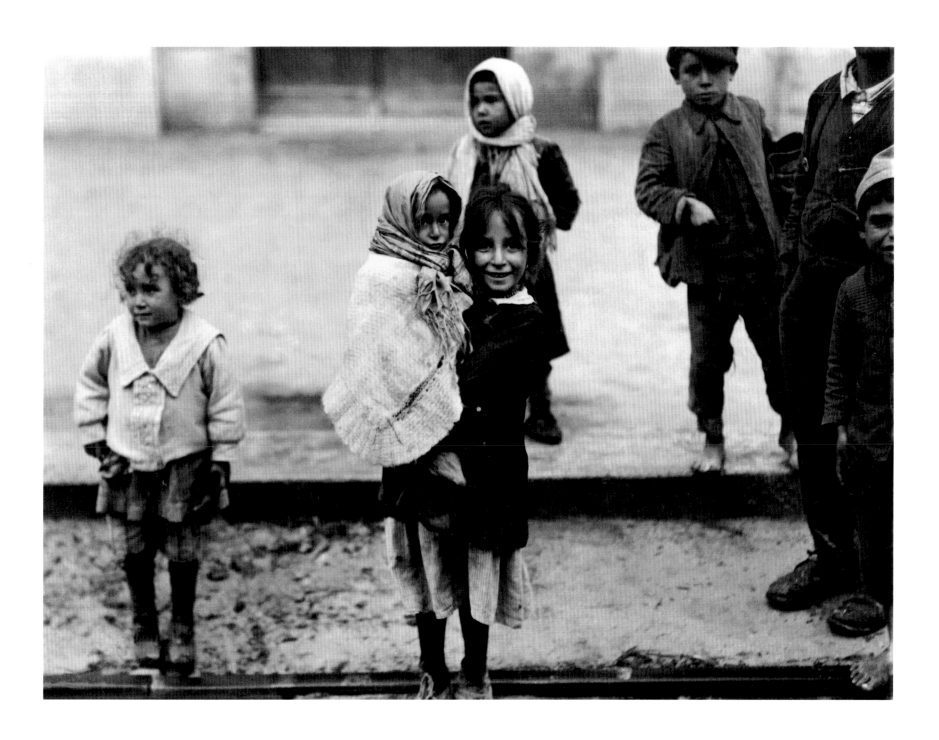

F. HOLLAND DAY. *Girl in Dress with White Collar*. Gum bichromate print. 1905.

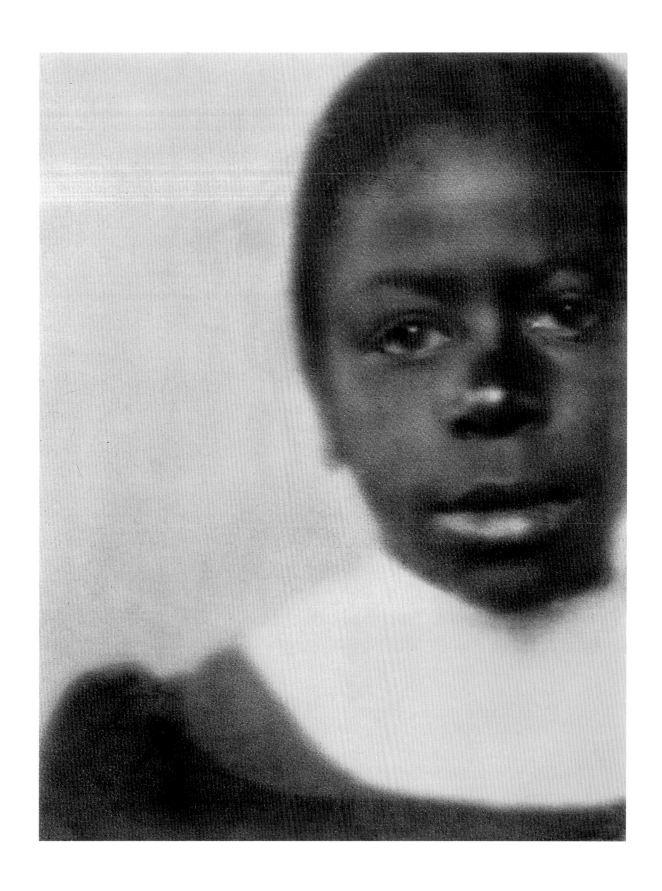

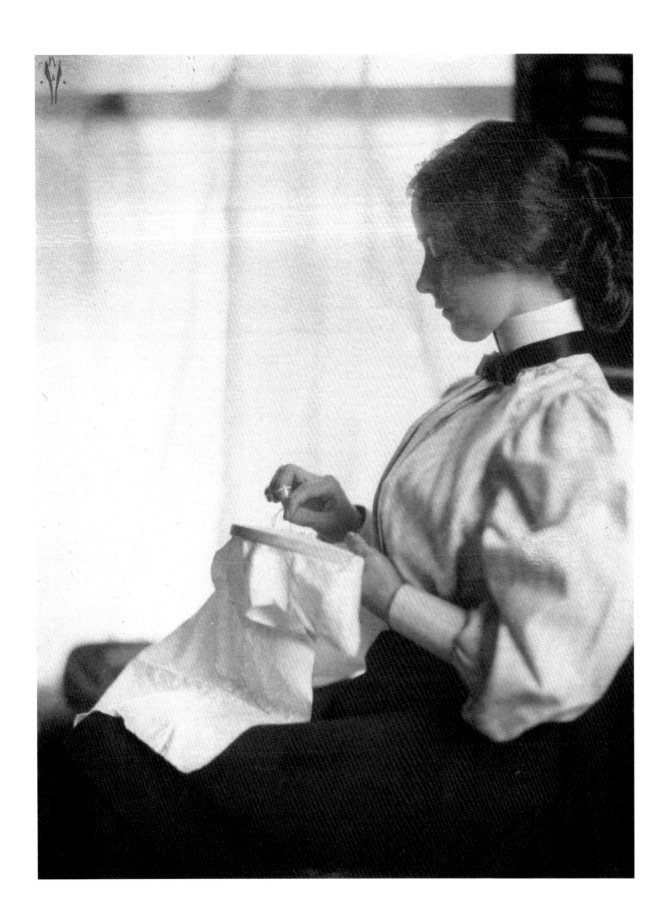

THEODOR JUNG. *Kids.* Gelatin silver print. Jackson, Ohio, 1936.

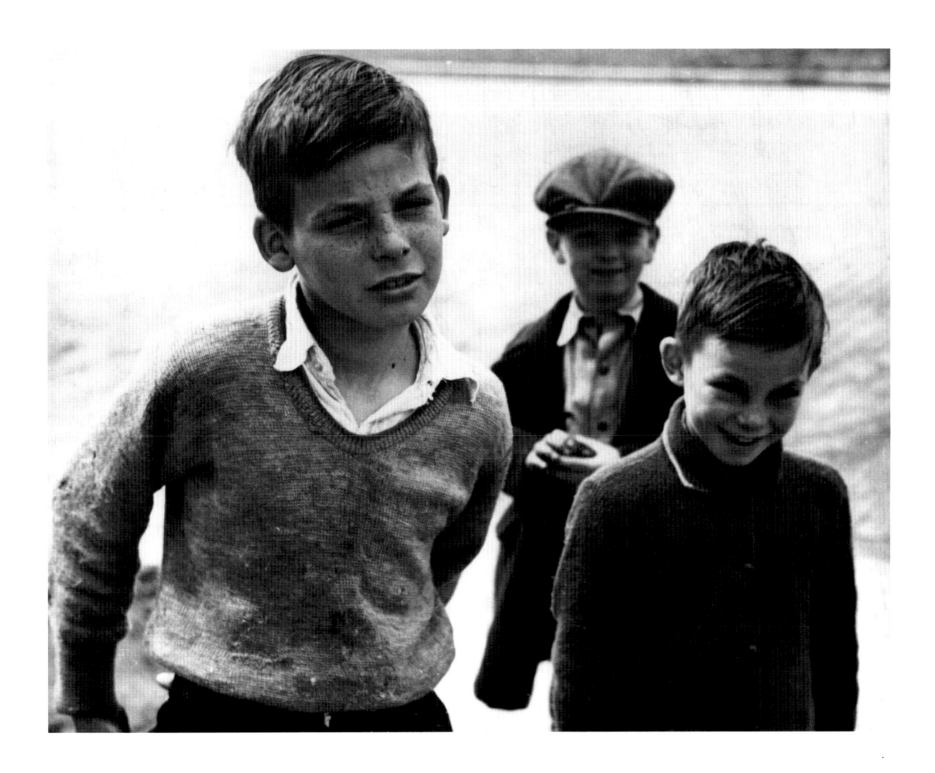

MORE CHILDREN AWAIT US, needless to say, as two distinguished and sensitively thoughtful photographers, also at work in the troubled 1940s, pay tribute to the loveliness (human as well as aesthetic) one's eyes encounter when catching sight of the young: John Vachon's Ozark girls, one reaching for the mail, the other a close compatriot in manner, the two virtually one, and Marion Post Wolcott's *Mother and Child,* who live at the time in Belle Glade, Florida, at the edge of Lake Okeechobee, where some of us who have worked with migrant farm workers have rarely been privileged to encounter the proudly protective parental dignity this particular picture presents. The mother's beaming smile and her arm's firm hold both defy all the burdensome hours that planting and picking crops require.

JOHN VACHON. *Ozark Children Getting Mail from RFD Box.* Gelatin silver print. Missouri, 1940.

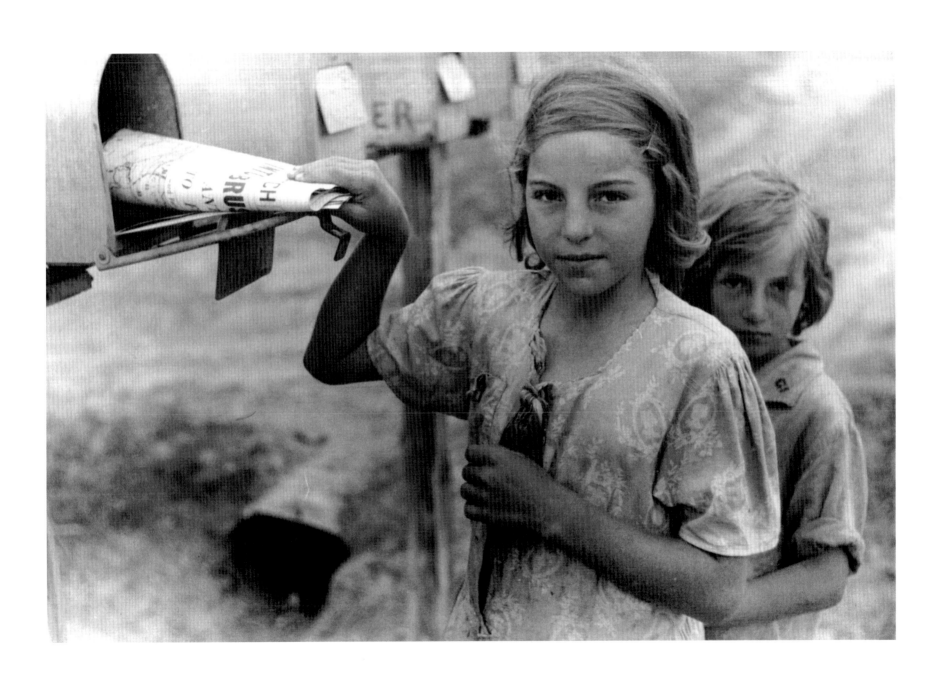

MARION POST WOLCOTT. *Mother and Child.* Gelatin silver print. Belle Glade, Florida, 1940.

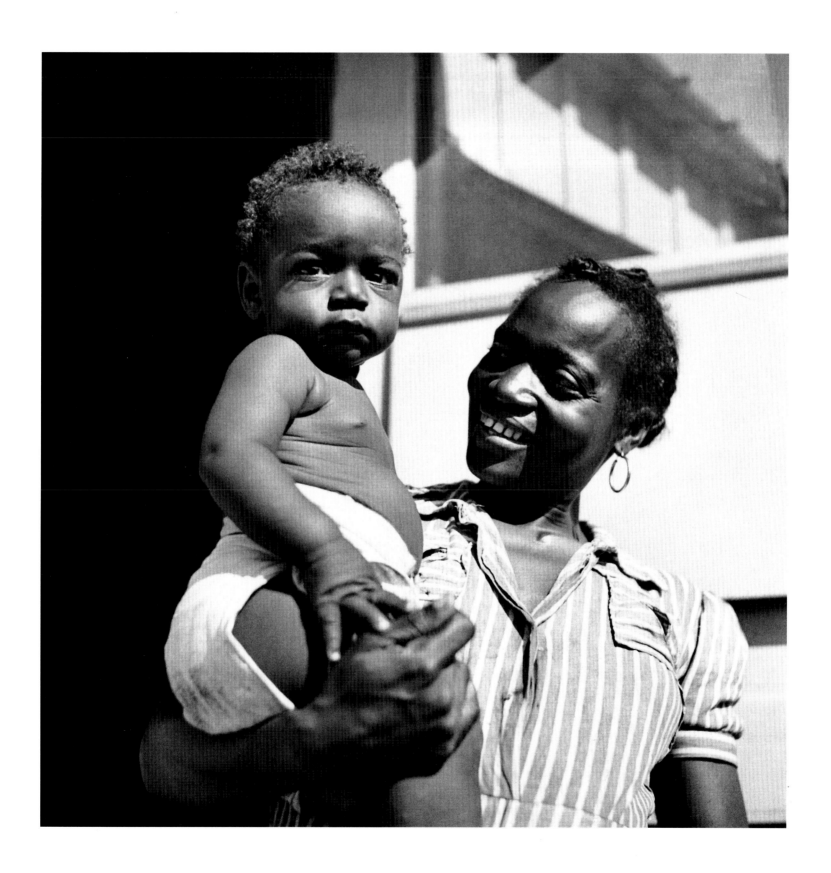

GOING BACK INTO THE RECESSES OF HISTORY, an unknown mid-nineteenth century photographer stirs us toward irony—a girl holding a daguerreotype case. Her life is similarly encased, but our eyes bring her to life, as hers stare at us so directly. Following her, a child born in the late nineteenth century holds a ladle, as if awaiting a chance to try things out, to wield the instrument at hand. Also back in that century, a photographer connects us to Tad Lincoln, our greatest president's son, attired in a Union uniform, a sword at his ready. Looking toward him, on the next page, is Carl Werntz' *Apache Girl,* dressed so beautifully, her basket so gracefully borne, her bearing a profile in forbearing charm.

PHOTOGRAPHER UNKNOWN. *Girl Holding Daguerreotype Case.* Sixth-plate daguerreotype. 1847.

32

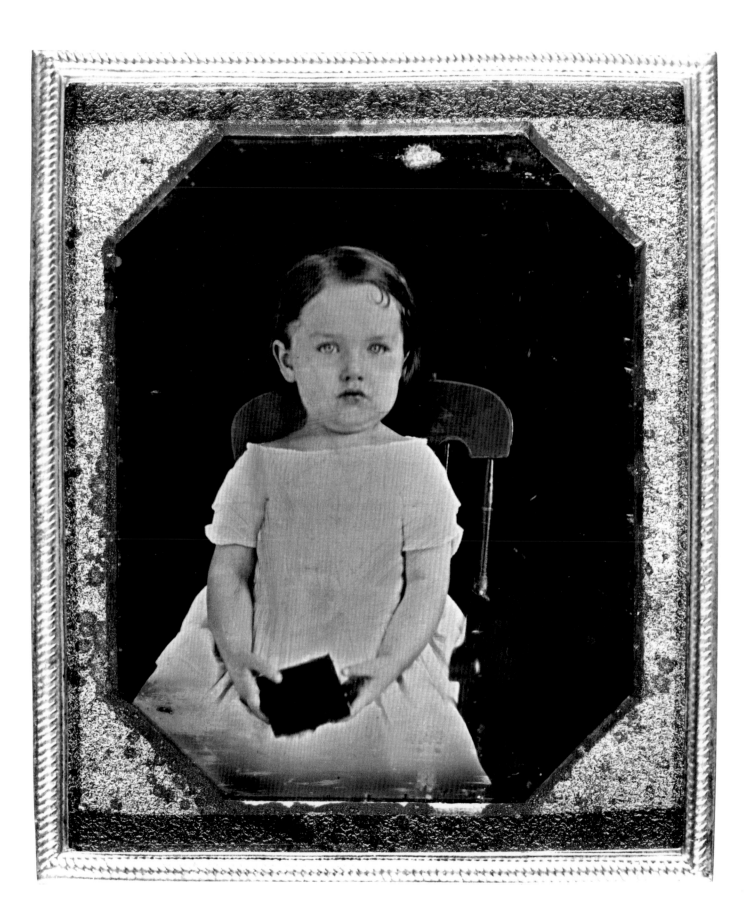

FRANCES BENJAMIN JOHNSTON. *Baby With Ladle*. Gelatin silver print. World's Columbian Exposition, Chicago, Illinois, 1891 or 1892.

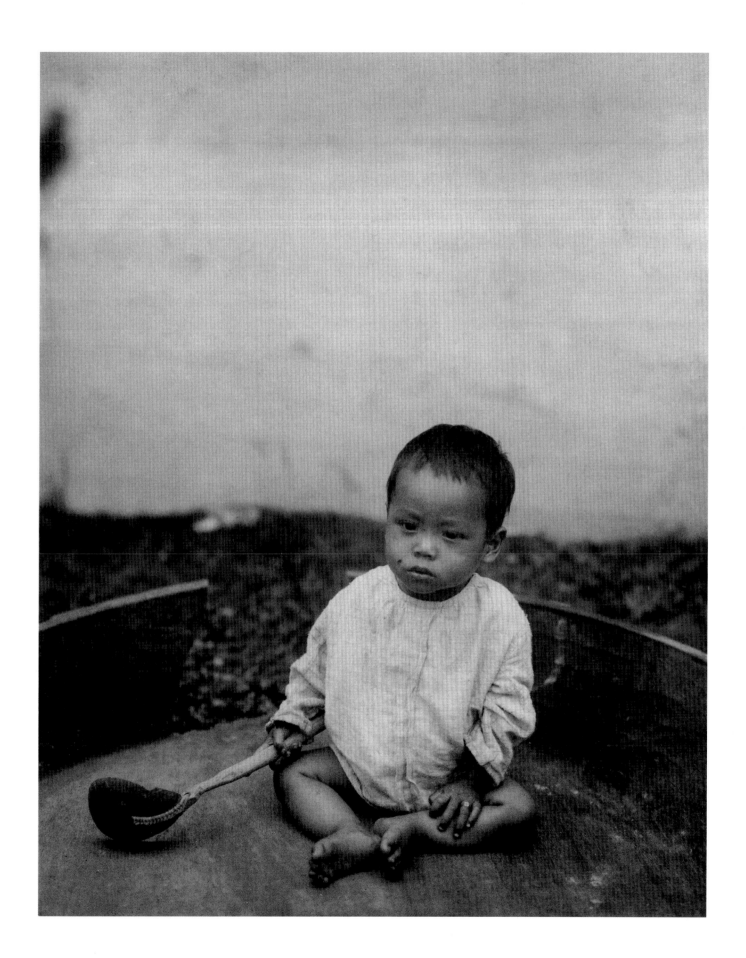

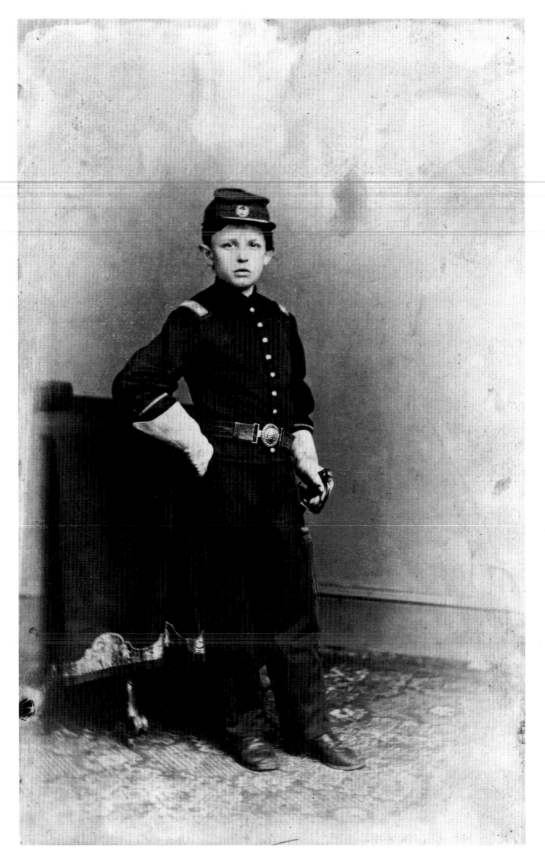

PHOTOGRAPHER UNKNOWN. *Tad Lincoln, Son of President Abraham Lincoln.* Early 1860s.

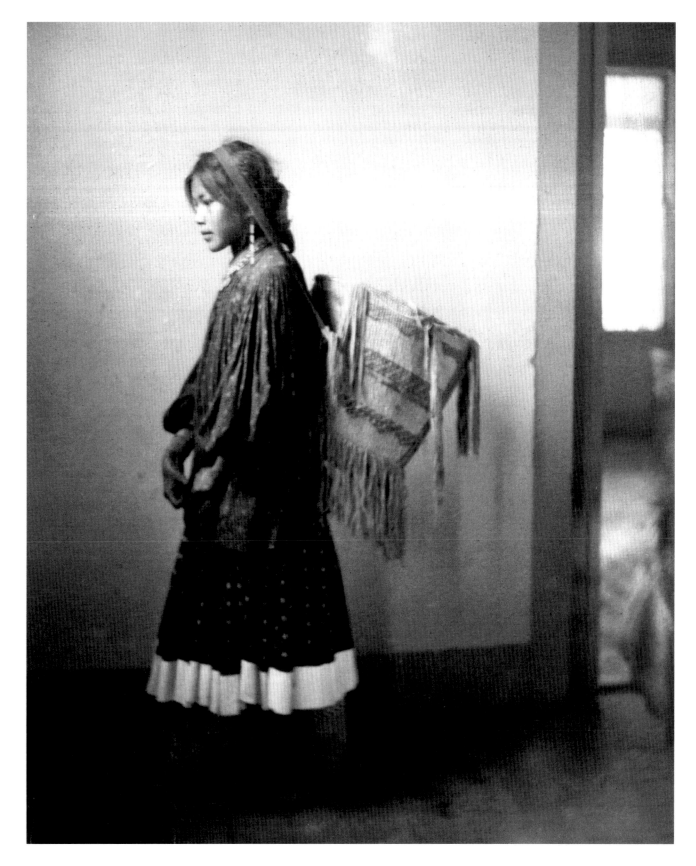

CARL WERNTZ. *Apache Girl*. Gelatin silver print. Circa 1902.

(many of us parents and grandparents, too) and so it does the boys and girls whom Marion Post Wolcott, Theodor Horydczak, and a photographer for the H. C. White Company found themselves viewing, then catching for others similarly to eye. For one of the Louisiana boys Wolcott witnessed, the water stretching far toward the horizon is a giant summons, which soon enough, one hopes, will affirm a youth's competence. As his body arches forward, unafraid, daring, his pal looks camera-ward, perhaps preferring to watch a scene being put on the record before taking on himself the protagonist's plunge. A third boy's head figures at the picture's bottom, telling us of a lineup—piers receiving plenty of human business from American boys inclined not to shirk a swimming opportunity. Indeed, Wolcott's picture captures not only boys queuing up for a leap, but youngsters showing a yearning, if not an expectant aspect of accelerating lives.

This brings to mind a boy of ten, also in Louisiana, who once indicated to an interviewer with respect to himself: "You see that lake," he remarked as the two of them stood in Covington, near Lake Pontchartrain, and then these words meant to convey the thinking and feeling which together can preceed and inform action: "I like to look and look at all that water and try to guess how far I could go if I really tried it, swimming and swimming. Would I be able to get to the other side, or would I be wasted—and then what would happen? Once you're on your way, you're in a jam. See what I mean? When you start out on a swim, you're all set to stroke with your arms and kick with your legs, and the next thing you know, you're in there, water all around you, and

Farm Boys Swimming. Gelatin silver print. Lake Providence, Louisiana, 1940.

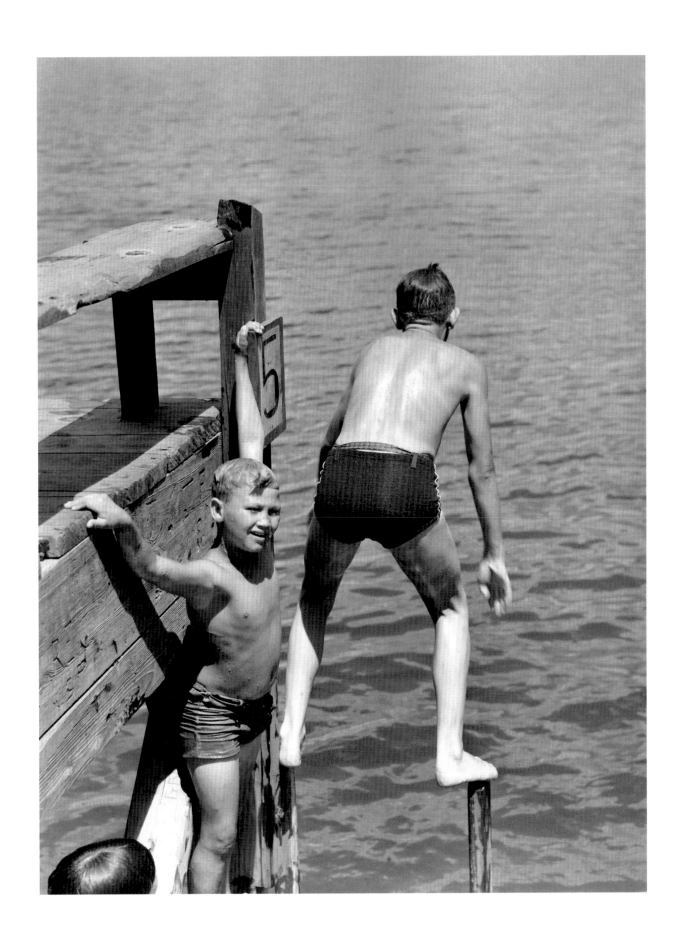

your body showing you it can handle it, and take you wherever you want to go. But after a while, your body can start talking back—it can say, 'hey buddy, there's a limit here, so you better bring this trip to a close!' The muscles are getting tired, and they don't just go and go without an ache, and you're smart enough to know that this show could be over if you don't use your head, and do something before there's cramps and more cramps, and you're worn down bad, real bad, and either you can stand to walk out, because you're near the shore, or you're in 'big trouble,' like my dad says, and then you sure hope there's someone out there, nearby, keeping an eye on you, and ready to come rescue you—so, you get ready to breathe and breathe, and to float and float."

Yet, as the very title of Mr. Horydczak's picture reminds us, water can be beckoning all right, though also friendly—a sanctuary of sorts for those who are inclined to connect with nature as grateful recipients of its offerings. The swimming hole becomes a place of assembly, as in a kitchen, or a living room, or the front or the back porch—and, too, a piece of self-presentation amidst the familial crowd, hence the mix of solemnity and frivolity on the faces of these children, each with his or her story to tell, even as, together, they assert the willfulness of boys and girls old enough to stand on their own, enter and leave a particular body of water, which in this picture offers a collective platform.

And water can be exciting and exhilarating in its danger. Throwing all caution aside, the Nubian boys in a frame from a turn-of-the-last-century photograph smile for the camera as they balance precariously on logs drawn by the magnetic and mesmerizing current of the Nile.

THEODOR HORYDCZAK. *Six Children at Swimming Hole.* Gelatin silver print. Circa 1920–1950.

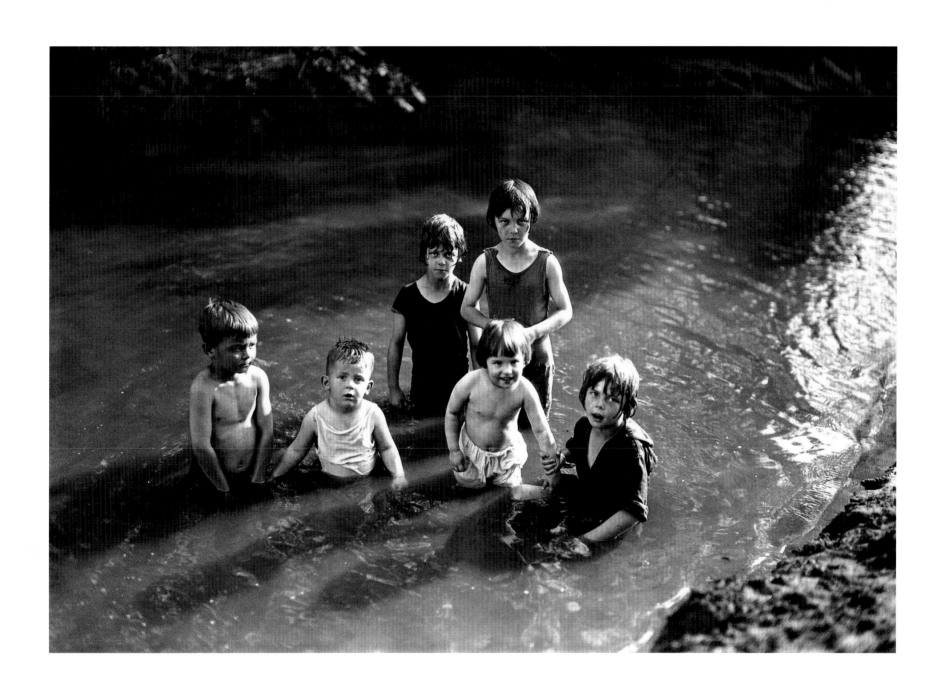

H.C. WHITE COMPANY. *Nubian Boys Shooting the Rapids of the Nile.* Stereograph. Egypt, circa 1901.

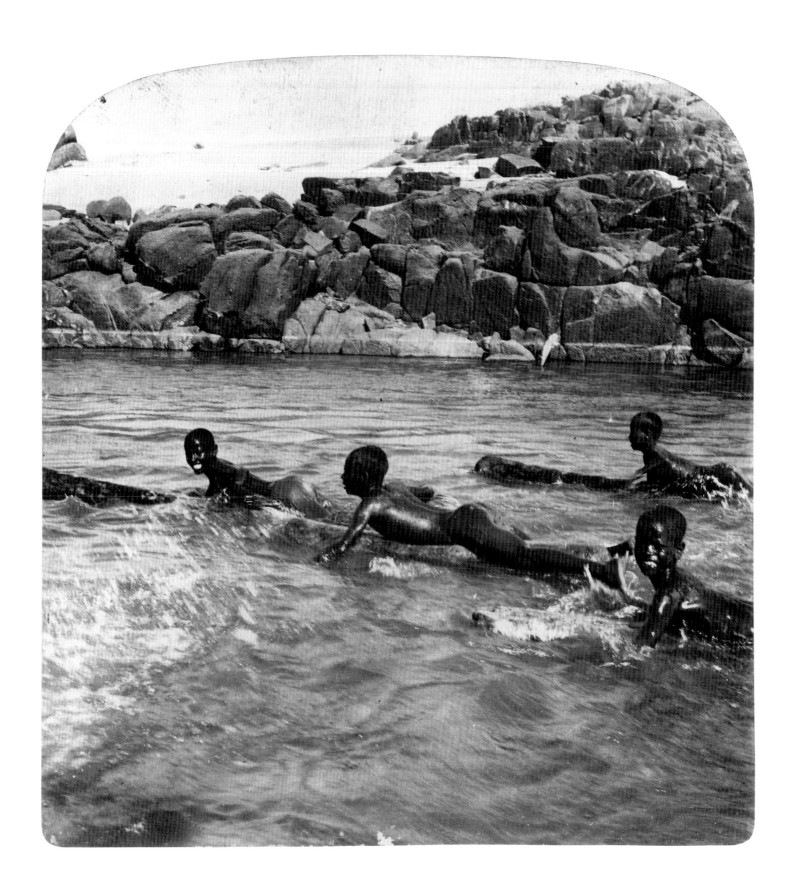

NOT THAT WATER IS THE ONLY PLACE for children to play or pose. In the pictures that follow, land offers its support, as does a school bus, a sidewalk, even a building's beam. The children are upright and still, or seated, or bent and huddled. Jack Delano found in Puerto Rico a boy whose hat and folded arms suggest an ironic prominence of self-confidence in a humble, agricultural scene. We viewers can only wonder what this farm boy is thinking, even as we, distant from him by virtue of space and time, can call upon him for our own imagined stories—a child eager and willing to let a man with a camera snap away, or a child watching with consternation, maybe even reluctance or removal, as a photographer requests or pleads for a moment's posing cooperation. And that hat, we may wonder—a story in itself, perhaps?

JACK DELANO. *Farm Boy along the Road.* Gelatin silver print. Corozal, Puerto Rico, 1941.

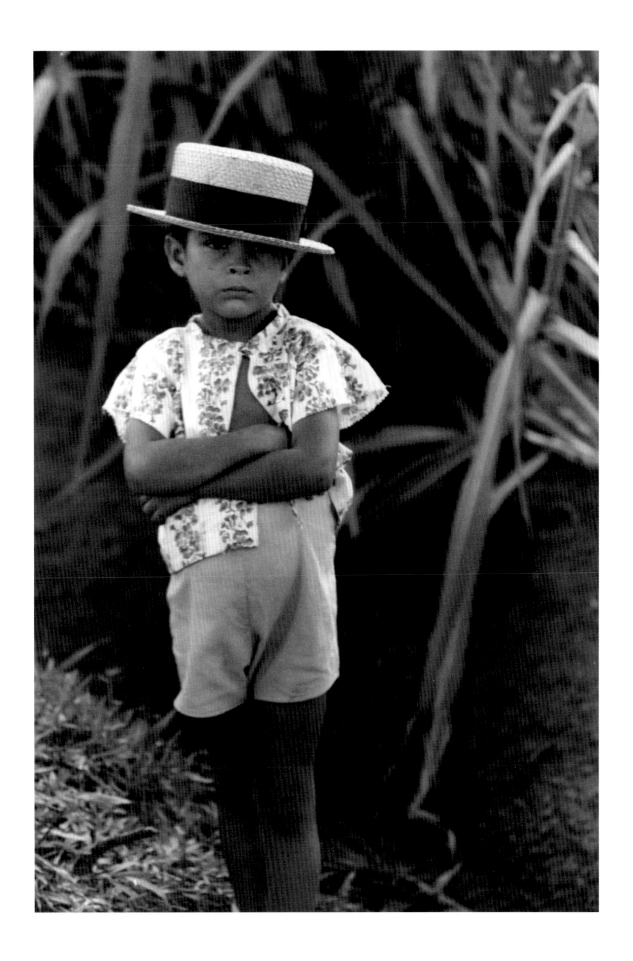

A HAT ALSO HOLDS OUR EYES in Edwin Roskam's picture of a boy all dressed up for one of Chicago's Easter parades. He and his hat-covered predecessor in this volume were both put on record for all of us in the same year, as the world was plunging ever more deeply into the worst of international wars. These two seem solidly secure in their respective situations. Roskam's youngster wearing his coat jacket and tie, his trousers and shoes, quite elegantly. All that formality is topped by an almost rakish hat, slightly tilted to the wearer's right. Meanwhile, our contemporary eyes take note of a 1930s American car, its rear windows a pair of eyes. The car, for all we know, belongs to a well-to-do stranger, or to someone in the boy's family.

EDWIN ROSKAM. *Boy Dressed Up for the Easter Parade.* Gelatin silver print. Chicago, Illinois, 1941.

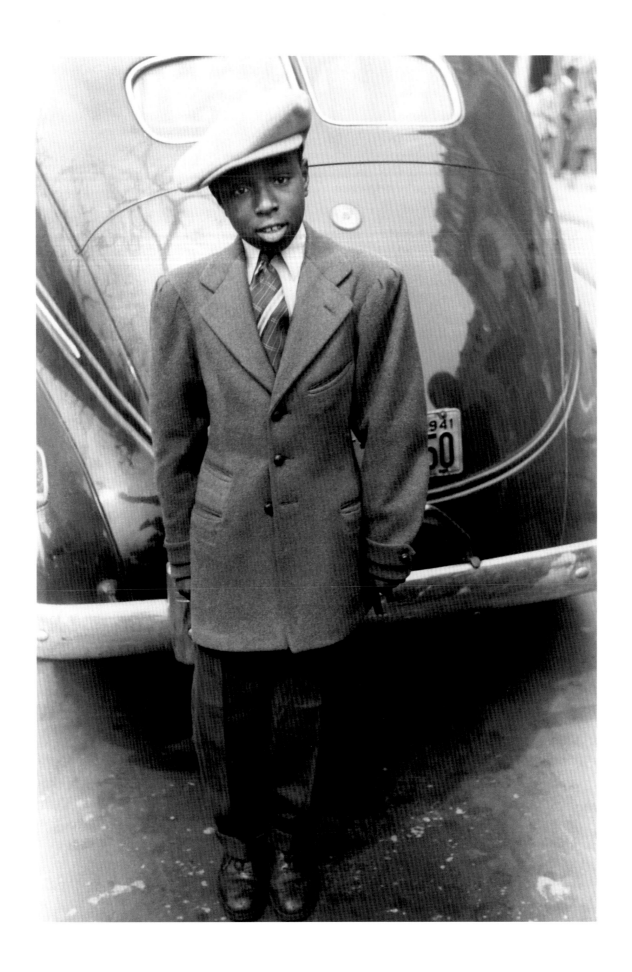

ANOTHER AFRICAN AMERICAN CHILD is connected to a moving vehicle, this one a bus, meant to carry a boy living among his own people to a white neighborhood. For him, his new school may be located in the great beyond that racial difference can signify for some children. So it went during the 1960s in certain American cities, as Southern troubles, long-standing racial discontents, moved North. In that regard, John Vachon and Mary Ellen Mark went to Boston to capture the story of desegregation busing for *Look* magazine. In so doing, they found a moment that told of a long story through a single image, as a poem can sometimes do when a writer has a big picture he or she wants to convey pointedly—in this instance, a wide-eyed boy staring through a bus window, which frames his watchful, wondering face.

"I sure see a lot on that bus ride to school," an African American youngster of ten once told a Boston physician who was helping implement the very "Operation Exodus" this photograph was intended to document. His self-description might have explained correctly what was crossing the mind of this picture's traveling student. "I sit and take in things, I guess you could say." His mother used that expression and he'd oblige her quite often as he spoke of what passed him by as he sat on a bus that carried him from Boston's Roxbury neighborhood, where African American children lived, to Boston's far more well-to-do Back Bay section, where a once all-white school housed him and a few of his pals from nine in the morning until three in the afternoon.

When asked what he especially recalled "taking in," he was alertly forthright: "I

JOHN VACHON AND MARY ELLEN MARK. *Boy on School Bus,* from *Look Magazine* article "Operation Exodus." Gelatin silver print. Boston, Massachusetts, 1968.

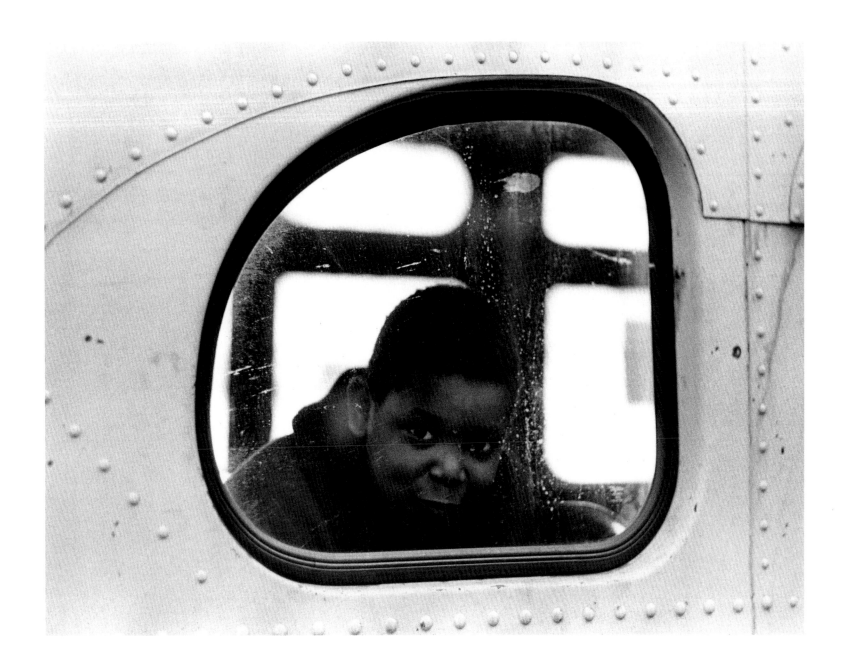

see people going about their business you know, they're on their way to work, walking or running. They'll look at the bus I'm on, and they know it's not the one they want for themselves—us colored kids on it. That's what I see in those white places, some looking at us, some looking away. You can see it on their faces if they're for you or against. My dad says, 'In life, people are with you, or they're not.' That's what I'll be thinking as I look out. Every once in a while, though, I let myself go on a trip—there'll be a store, or a building, where they'll be selling cars, and I think that place looks real cool, and if I had the dough, then I'd just try to be real relaxed, and walk in, as if it was my right, and there'd be no one saying something bad." So it went, a boy on a bus, "taking in things," trying to find hope and possibility for himself, amidst the experienced vulnerability and outright jeopardy he knew so well to be his fate.

Perhaps as that boy traveled, he saw other children going about their respective ways, as we are able to do in these pages. Across continents and countries boys come together, spend time together, a prelude to their membership in one or another community, or nation. Carl Mydans gives us boys playing cards near Washington's Union Station, and we quickly become as attentive as the youngsters attending ever so watchfully their cards.

Again, the physician recalls a story of chance and fate, an outcome of a child's card-playing interest: "You win or you lose, it's all whether you're lucky that day, or not. My mom tells us to try, but not to forget that in life, it's the roll of the dice, or the hand

CARL MYDANS. *Boys Playing Cards near Union Station.* Gelatin silver print. Washington, D.C., 1935.

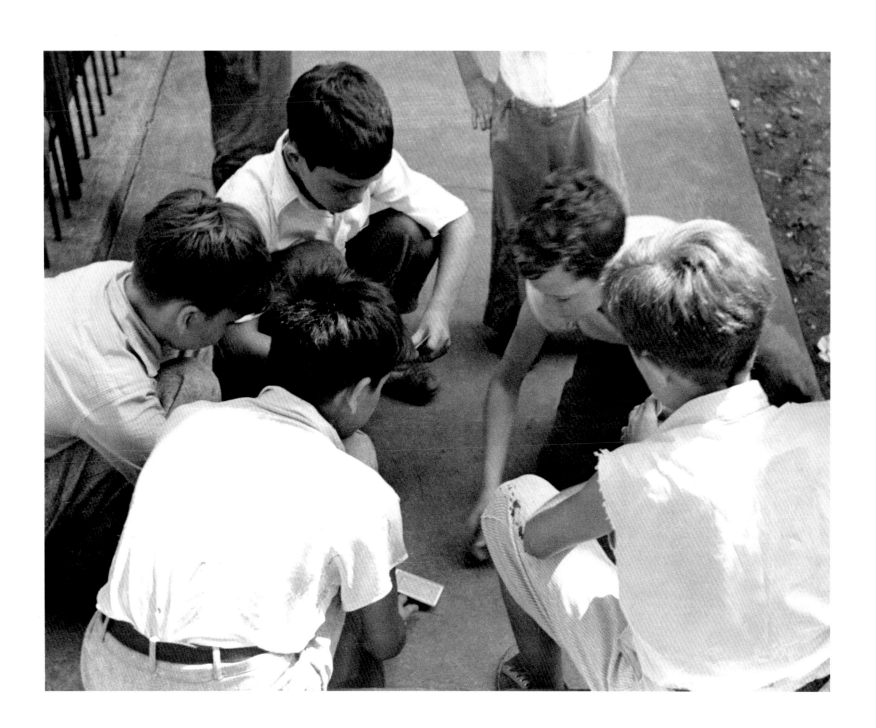

you get when the cards are being dished out. So I try not to take things personally."

He had more to add. His older sister had recently taken ill with leukemia, and the terrible, scary experience that had visited an entire family prompted in him lots of questions and worries about life's arbitrariness. Similarly, in games played on counters or desks in homes or on a street, huddled participants take their chances, plan and plot, yearn and feel the pang of disappointment.

Marcus Clark's Parisian children are enjoying, in 1939, a fabled city's street as if it had become theirs alone—no adults to bother them or threaten them off. All too soon, we know, things would change tragically in France's capital city. The Nazis would rule. Their tanks would rumble down the street we see and their planes hover over it.

MARCUS J. CLARK. *Children at Play in Narrow Street* . Gelatin silver print. Paris, France, 1939.

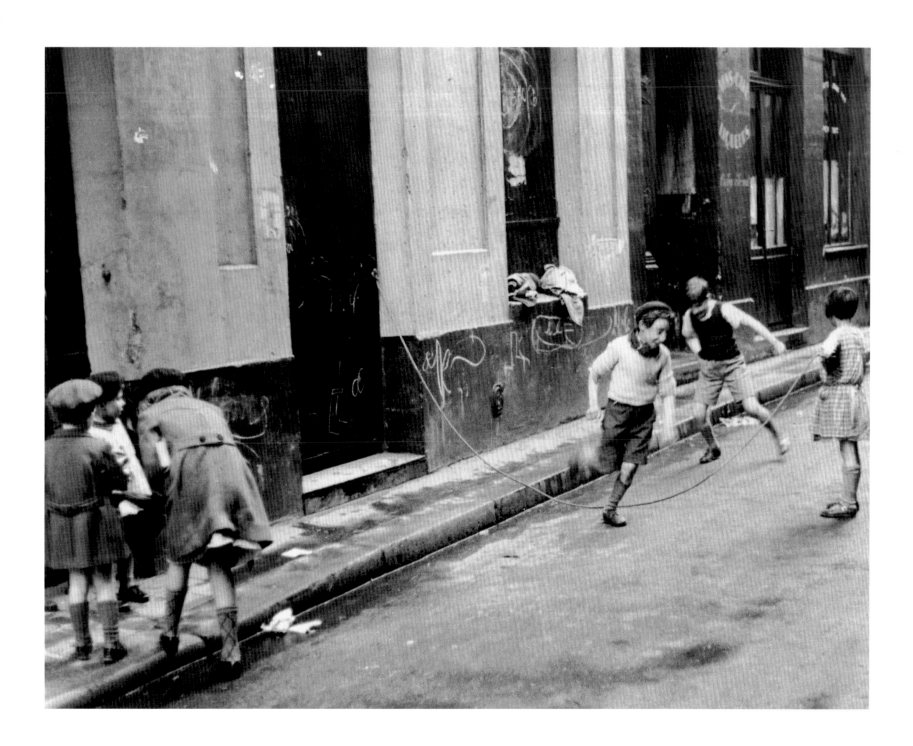

ACROSS THE OCEAN, IT WOULD BE DIFFERENT for the boys Aaron Siskind observed. They are in New York City's Harlem, and the two cars on the street tell us that the time is the 1930s. The world is readying for a war that would engage the fighting spirit of millions of people across the continents, and these young Americans are at their own sword's point—taking measure of one another's alacrity, agility. One wonders about the apartment building, which the beam that holds three of the four boys cuts almost in half. Who lives in that place? The windows offer no clues, almost like the dwellings in Edward Hopper's paintings, which sometimes convey an air of mystery. The windows guard their secrets, and it is left to us curious outsiders to speculate. But those boys let us know that there may well be fight in a neighborhood hardly booming with high prospects.

Russell Lee's undated picture of a Fourth of July parade brings us up close to another American realm and American values. Our country's birthday is a time of looking back and of looking around. So many of us are thankful to be here and not in any number of nations. We are excited by the chance to show and tell our American loyalties (their stirring meaning) as a collective.

AARON SISKIND. *Boys Playing with Toy Swords*. Gelatin silver print. Harlem, New York, circa 1930–1940.

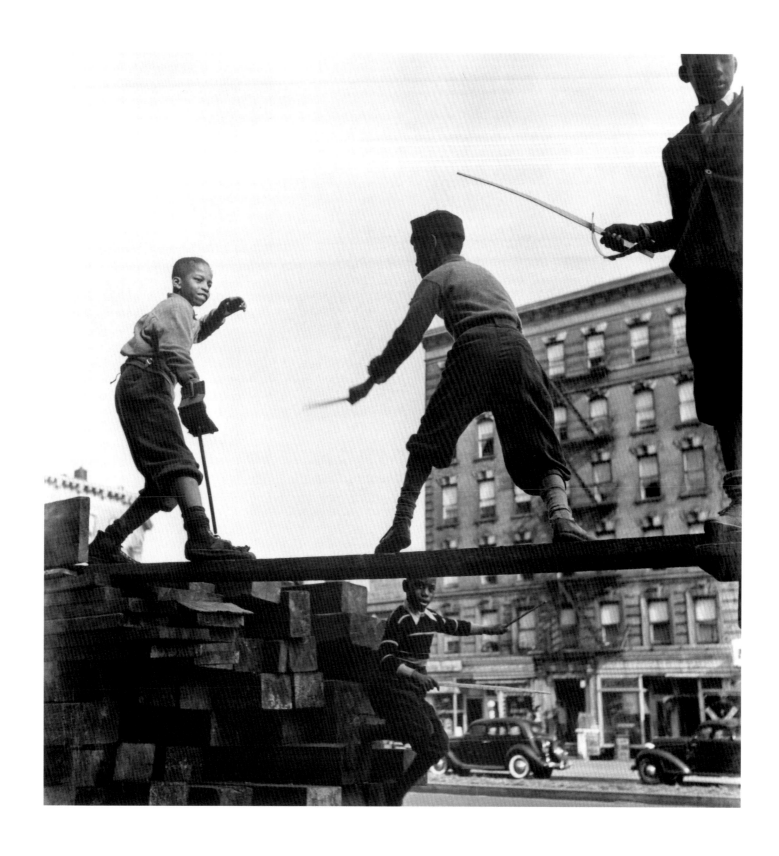

RUSSELL LEE. *July 4th Parade.* Gelatin silver print. Date unknown.

IT IS NOT EASY TO TURN AWAY from children, near and far, no matter the other obligations that press upon us. We want a future for this world, and when we look at boys and girls going about their ways and days, we are reminded of all that our sons and daughters need to do in the course of their short but important (sometimes momentous) lives spent here among us adults—and so our eyes meet theirs in pictures that become beacons for our moral sensibility, not to mention, our hearts. In Lewis Hine's *Drought Victim from Kentucky* from the early 1930s, the stately child holds in his right hand a much needed milk bottle, supplied, in this case, by the Red Cross, the straw in it a reminder of an enabling assistance.

Russell Lee's threesome at a table is also a portrait of winsome young Americans sitting side by side. Two give us a right-on look, the third keeps his own company, his eyes his very own to direct for objects, activities he sees fit to judge desirable. Beyond our American shores are two more of Lewis Hine's children. A fortunate Turkish lad carries his burden of Red Cross proffered food at the end of the first World War. Back to our country, a factory boy in Virginia labors at the end of the past century's first decade. He is a slender young man, his body's profile alongside a factory's equipment, under a pile of substantial width, even as adults busily work in the background. The boy has a lot to keep under his cap, but he is a seasoned worker, doing his level best to build an American economy whose strength would soar in the years ahead, leaving us to wonder about the future appearance and destiny of this child become a man.

LEWIS WICKES HINE. *Drought Victim from Kentucky.* Gelatin silver print. 1930 or 1931.

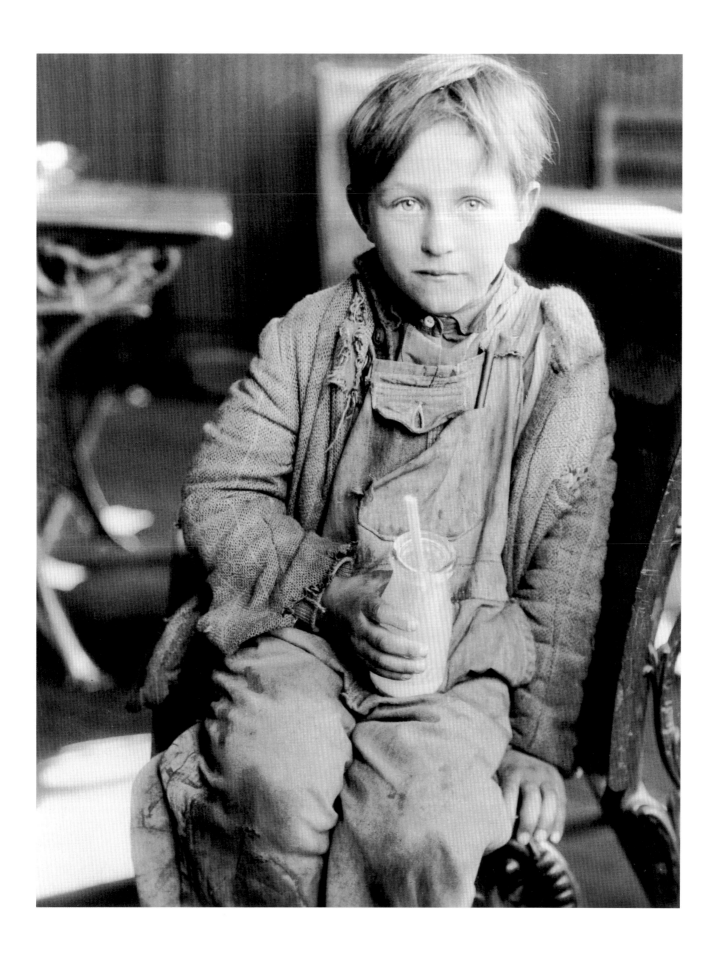

RUSSELL LEE. *Three Children at Table*. Gelatin silver print. 1930s.

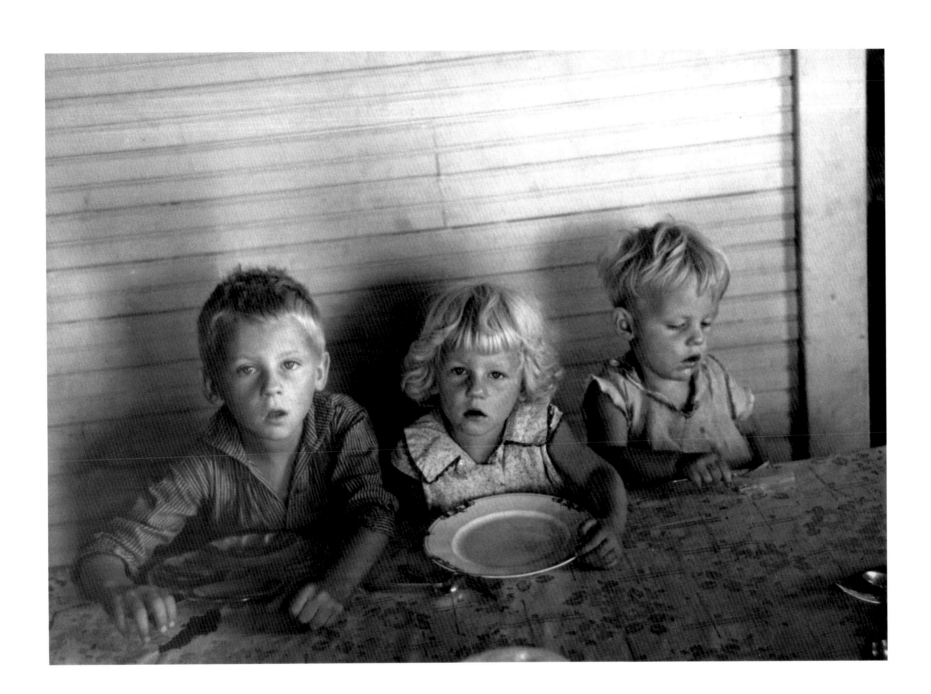

LEWIS WICKES HINE. *Turkish Boy Carrying Food.* Gelatin silver print. Salonika, Greece, 1918.

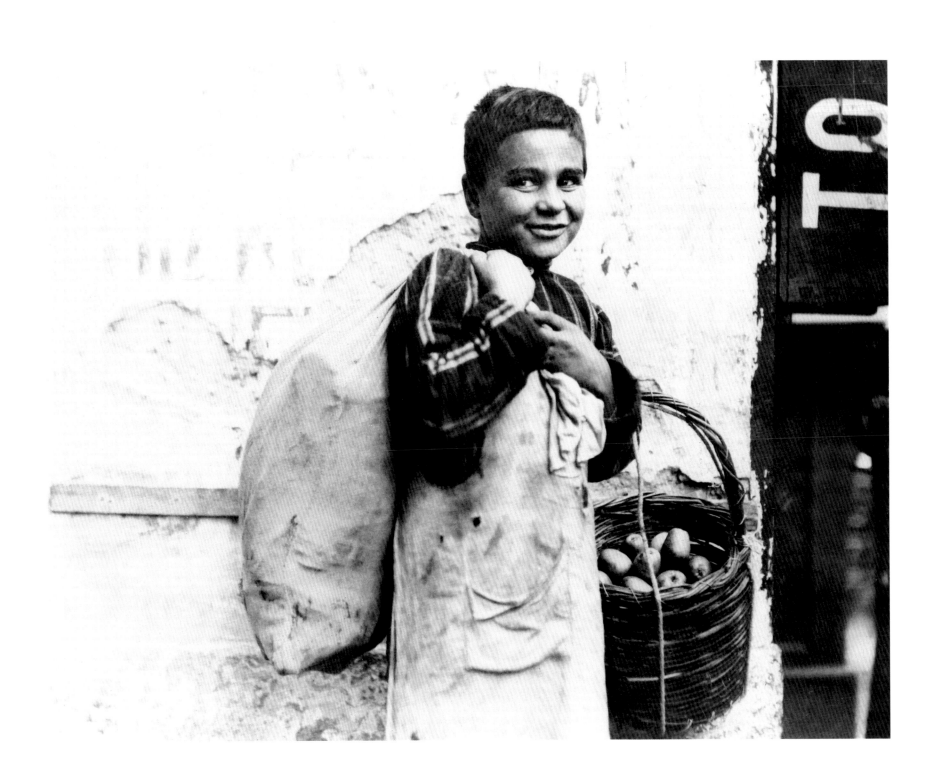

LEWIS WICKES HINE. *Boy Working in Factory.* Gelatin silver print. Alexandria, Virginia, 1911.

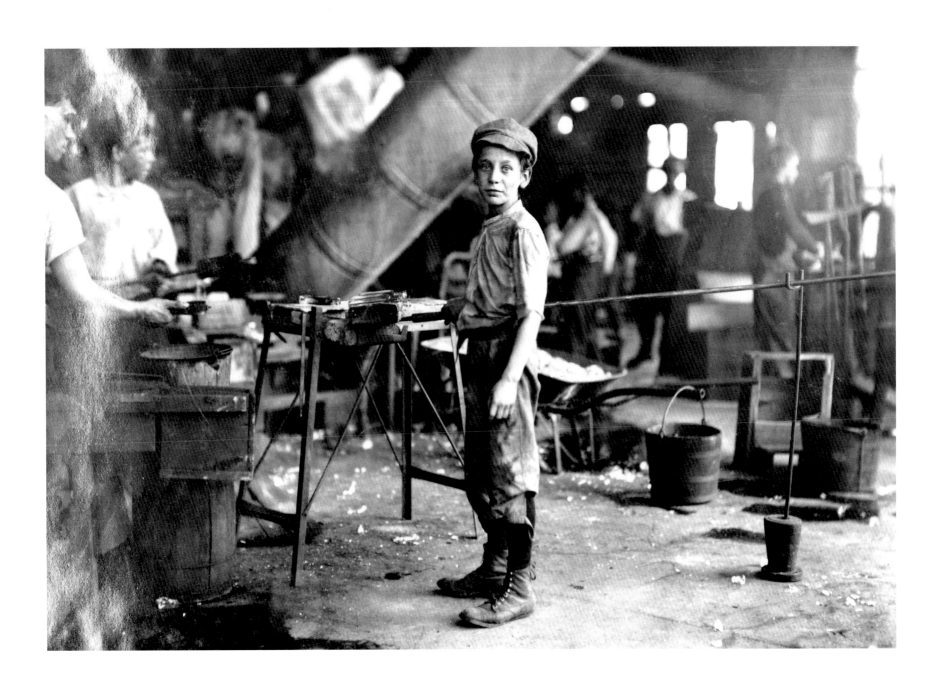

entering adulthood and two adults with children. F. Holland Day's moody portraits show young adults in what might have been the last formal photographic sittings of their childhood. Walter Scott Schinn's presentation of our first President Roosevelt, his strong arms protecting two boys, and Toni Frissell's image of a most distinguished English grandmother (Lady Churchill) touching and kissing her granddaughter reveal elders anxious to embrace the coming year through those they have come to hold above the temporary courtesies and exigencies of money and power.

Almost in the precise middle of this visual retrospective, we may begin to think of what awaits us as a compelling parade of peering and posing children passes our eyes, their presence defining the boundaries of space and time. Children need the caring concern of their parents, of course, but they also need the permission and encouragement to affirm themselves and to find themselves body and mind, both, no matter the disappointments and hurts that may besiege them. In one manner or another the young people in these pictures tell us who they have learned to become, what they have learned to want to do or take for granted. A small American boy is already a soldier during the Civil War. Many decades later Russell Lee shows us a boy with a toy gun watching a parade, his mom's crossed hands perched above his hat. The two boys are potential warriors, one appearing ready for battle, the other solemnly observant of a passing scene, his right hand at the ready.

F. HOLLAND DAY. *Nicholas Giancola.* Platinum print. Circa 1906.

F. HOLLAND DAY. *Tony in Sailor Suit.* Cyanotype. 1911.

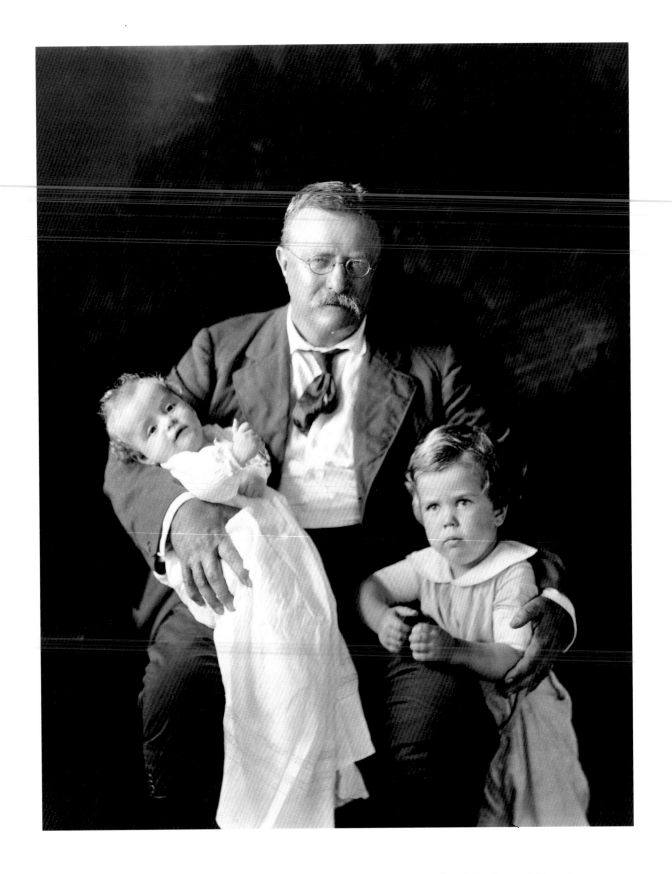

WALTER SCOTT SHINN. *Theodore Roosevelt with Master Richard Derby and Kermit Roosevelt, Jr.* Gelatin silver print. Circa 1916.

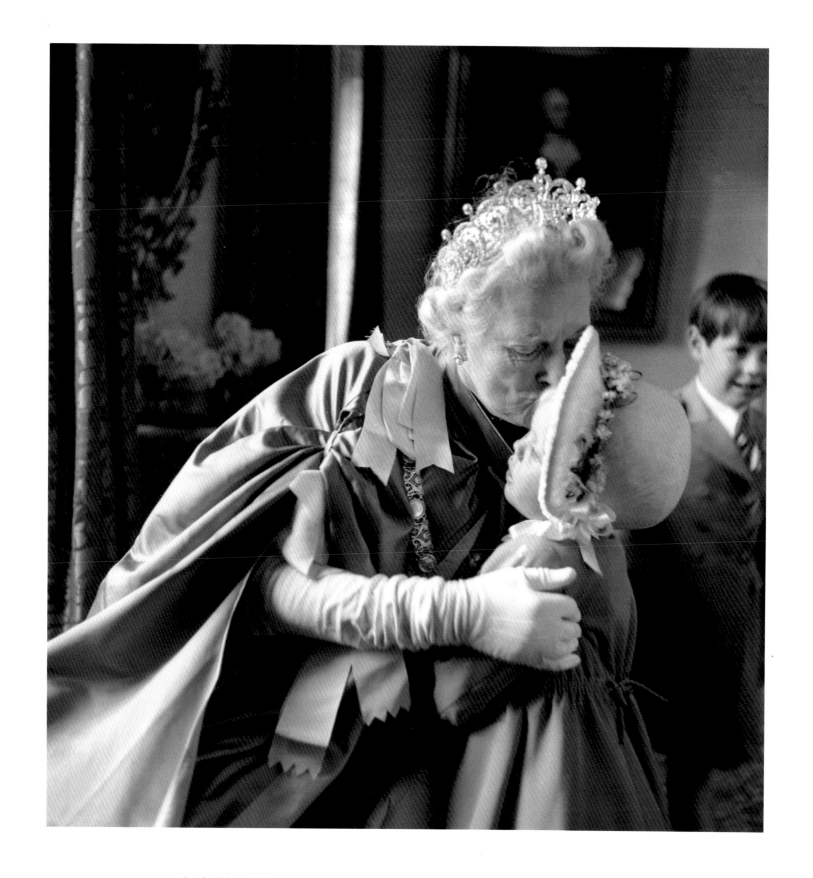

TONI FRISSELL. *Lady Churchill Kissing Granddaughter Emma*. Gelatin silver print. Circa 1950–1960.

MORRIS GALLERY OF THE CUMBERLAND. *Portrait of Boy Soldier.* Carte de visite. Nashville, Tennessee, circa 1860–1865.

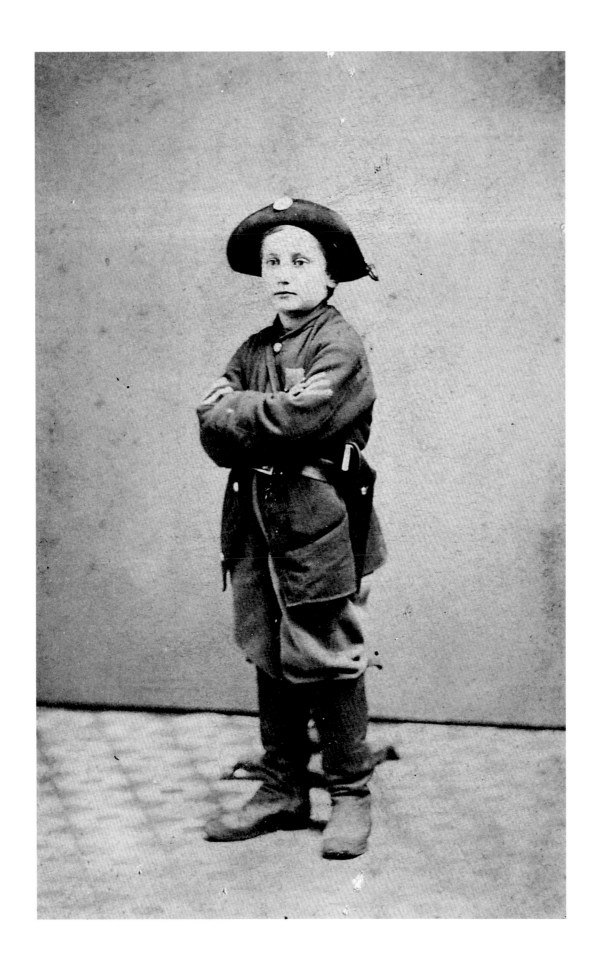

RUSSELL LEE. *Watching the Parade*. Gelatin silver print. Vale, Oregon, July 4, 1941.

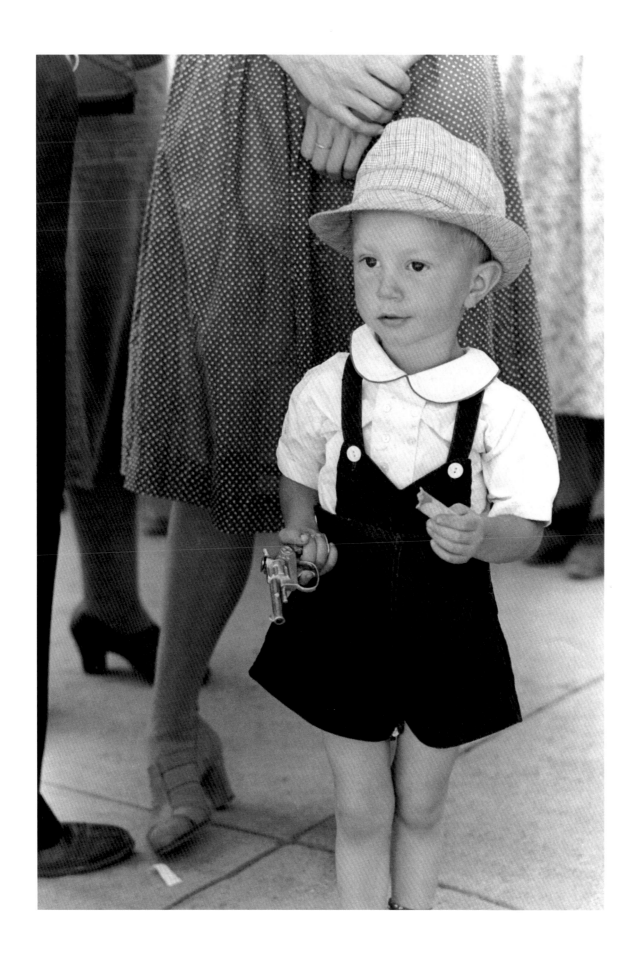

to a semblance of fighting, others have their own reasons to cry and cry, as a picture from the Alan Lomax Collection reminds us. The boy's vivid expression of regret and melancholy is countered by his dad's tender but firm hands, which aver human relatedness that is life's great treasure. Such parental reassurance (or that offered by others, even across lines of race and class, as shown in an image of a nursemaid by an unknown mid-nineteenth century photographer) allows a child to stand on his or her own, to test and try the body's possibilities, to stretch limbs, become a moment's wings, as Toni Frissell's two children do, or to clasp hands and cross legs becomingly, as the Lomax child singer does. Sometimes, of course, the hands thankfully hold more than each other: the food that enables life, and thereby, prompts expectation, hope, or an aspect of the material world that has come to hold meaning, value. Lewis Hine and Jack Delano give us those young hands as they do their chosen work. Hine's African American boy smiles so winningly, whereas Delano's son of a Puerto Rican farmer appears taken by thought, his eyes off elsewhere, his hat giving him a certain captivating presence and no small amount of distinction.

ALAN LOMAX COLLECTION. *Young Boy Crying.* Gelatin silver print. Between 1934 and 1950.

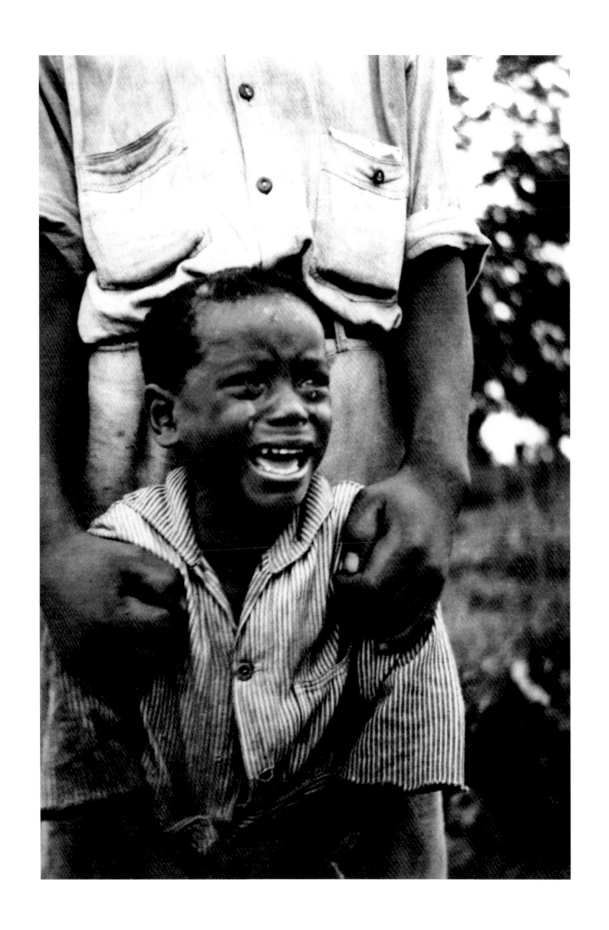

TONI FRISSELL. *Boy with Shadow*. Gelatin silver print. Circa 1950–1960.

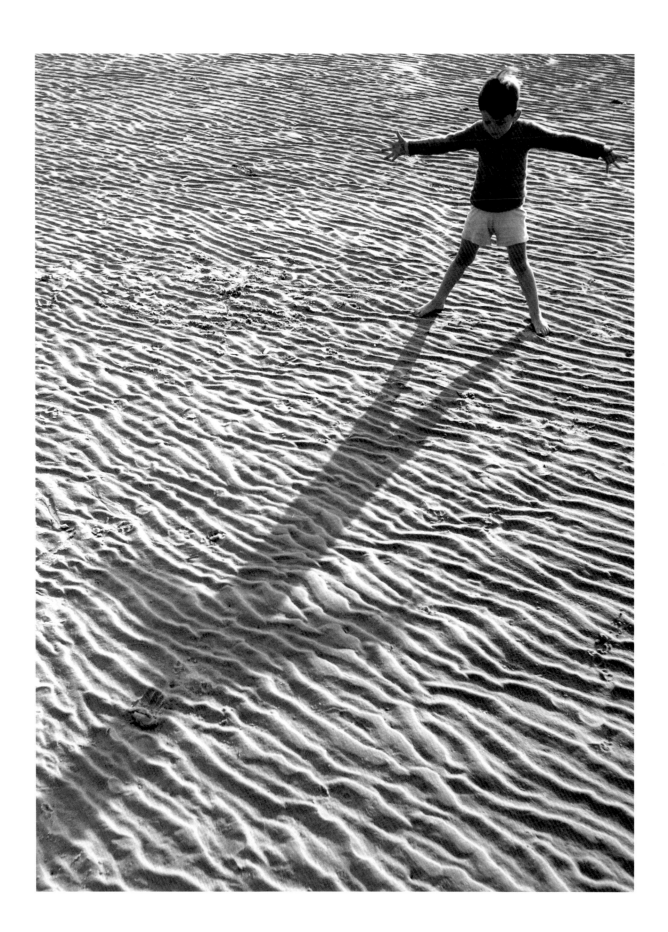

TONI FRISSELL. *Japanese Girl on Boat*. Gelatin silver print. Circa 1950–1960.

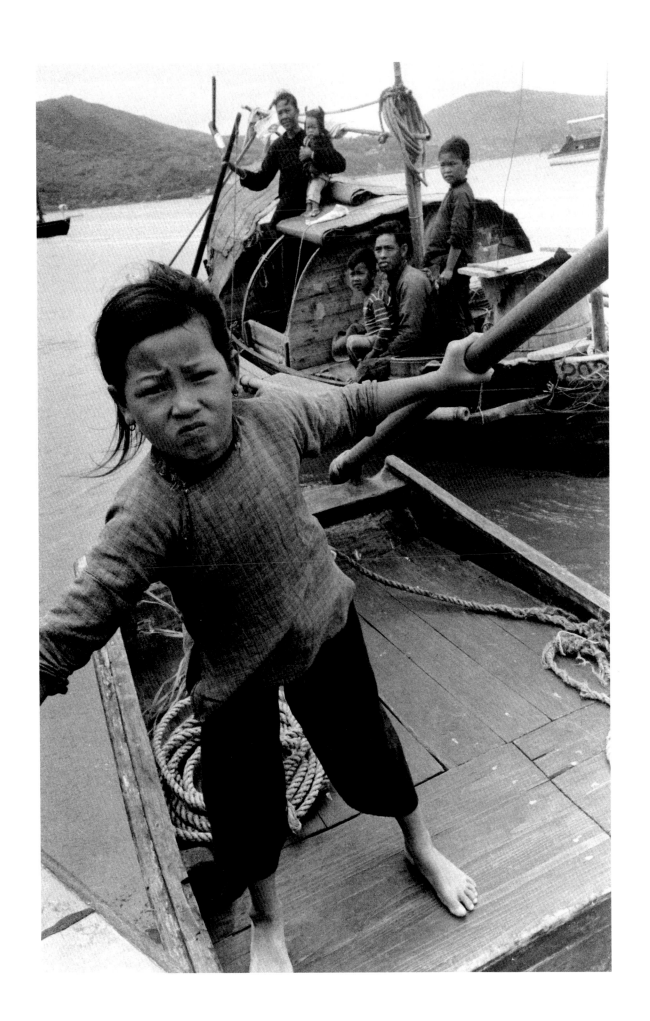

ALAN LOMAX. *African American Child Singer for Singing Games.* Gelatin silver print. Eatonville, Florida, 1935.

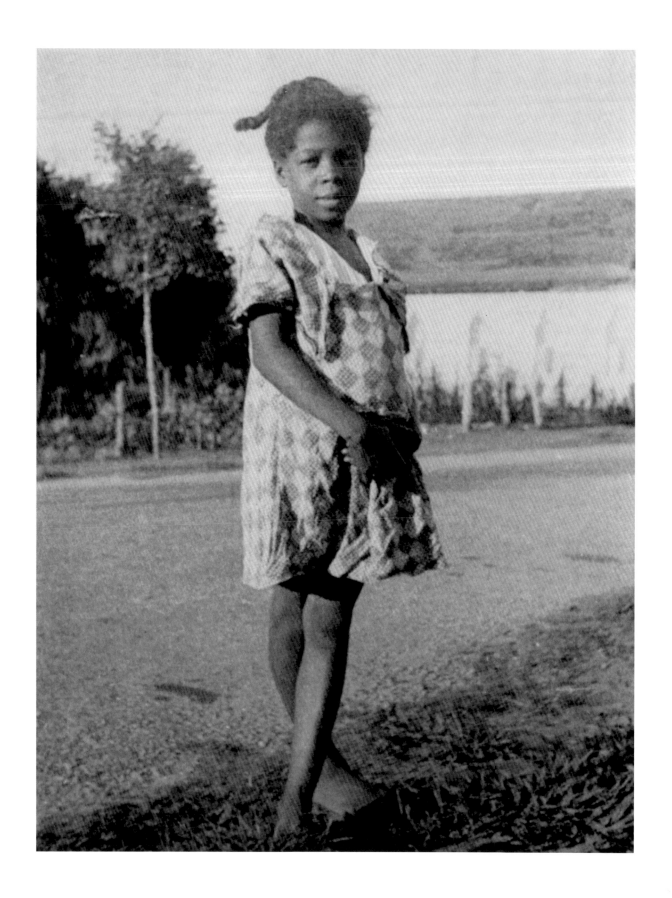

PHOTOGRAPHER UNKNOWN. *Nursemaid with Her Charge*. Sixth-plate ambrotype, hand-tinted. Circa 1855.

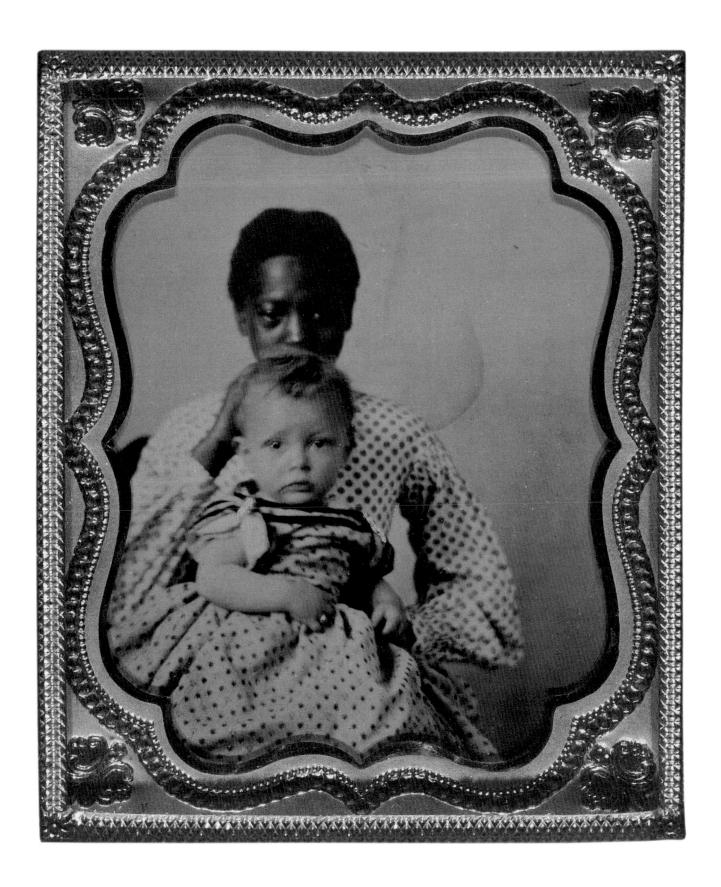

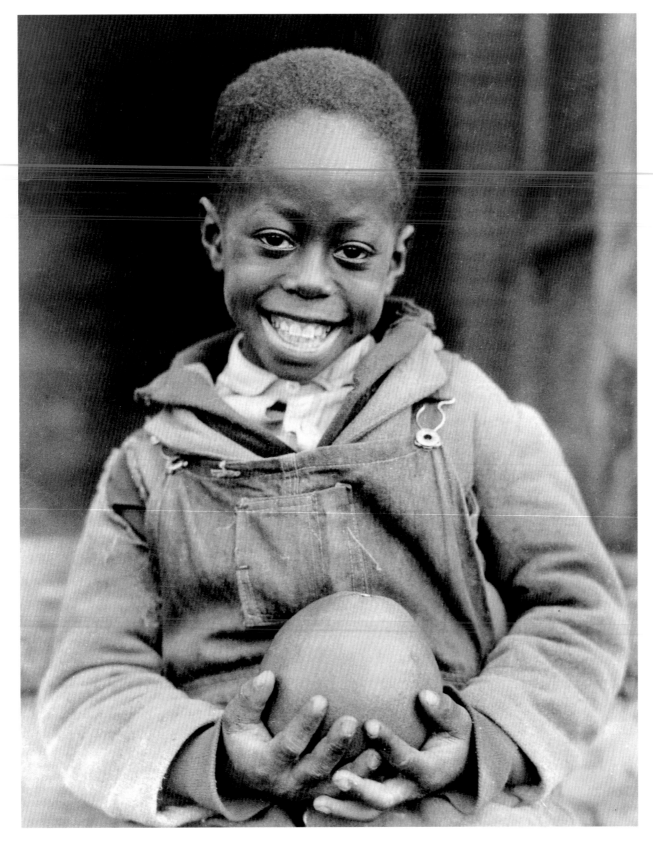

LEWIS WICKES HINE. *African American Boy Holding a Piece of Fruit.* Gelatin silver print.
Mississippi, 1930 or 1931.

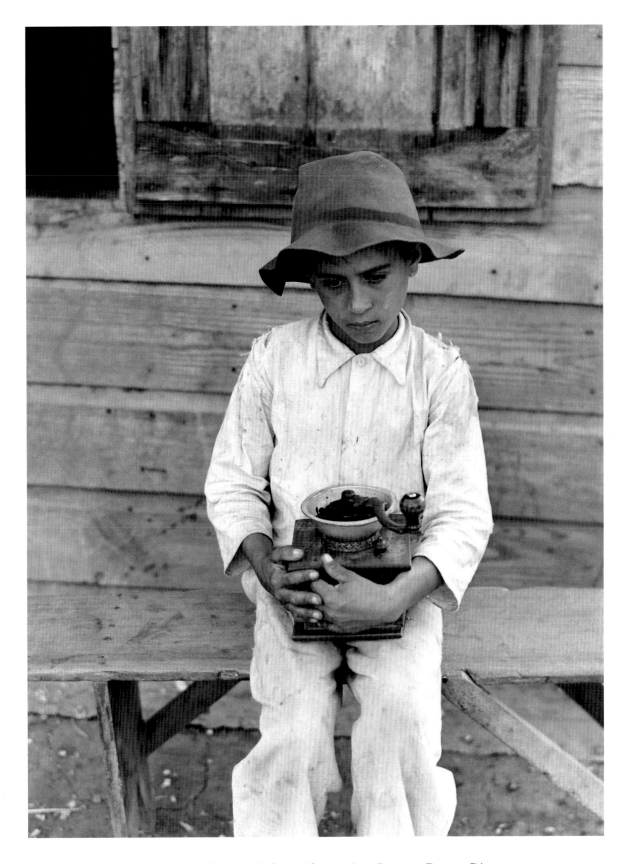

JACK DELANO. *Son of a Farmer.* Gelatin silver print. Caguas, Puerto Rico, 1941.

CLOTHES OFFER US NOT ONLY PROTECTION, but affirmation, if not identity. Our appearance tells us as well as those observing us who we happen to be. Theodor Horydczak's young girl seems almost bound in her attire, yet well able to sustain it, even as her ample hair tops off a self-presentation of trimness. After we meet her, we travel far west and north, courtesy of Edward Curtis, to a Cheyenne girl whose face is very much in tune to what is above and below it, and so with the Noatak and Tlakluit children who appear to be attractive instruments of the garments, the overall cultural dress, it could be called, that they both carry and give us as a gift to behold. The Eskimo child leaning on a block of wood seems, in contrast, very much observed, trying and yearning on her own.

THEODOR HORYDCZAK. *Copy Photograph of a Young Girl.* Gelatin silver print. Circa 1920–1950.

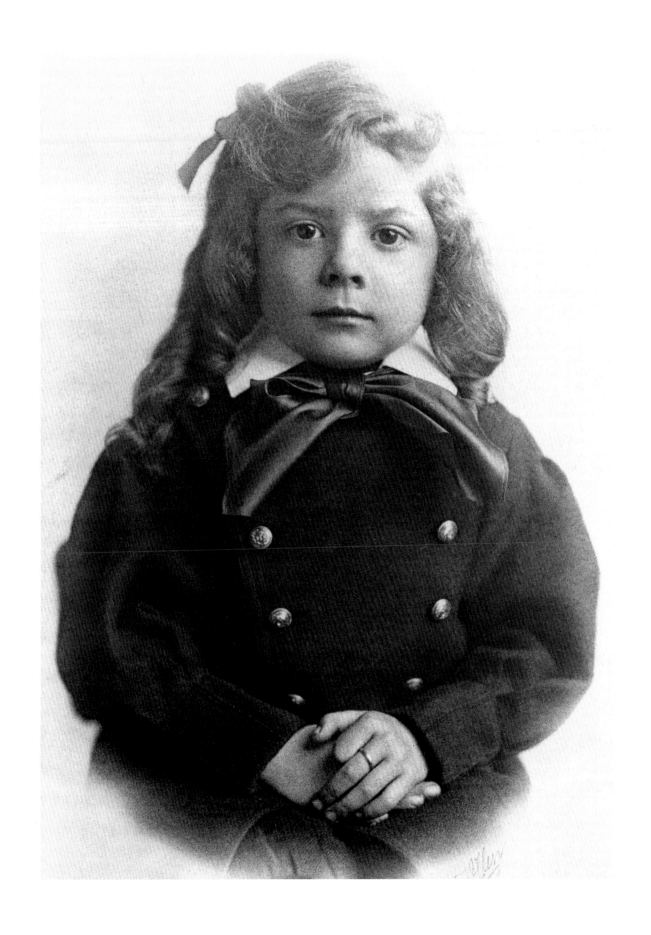

EDWARD S. CURTIS. *The Daughter of Bad Horses (Cheyenne).* Gelatin silver print. Circa 1905.

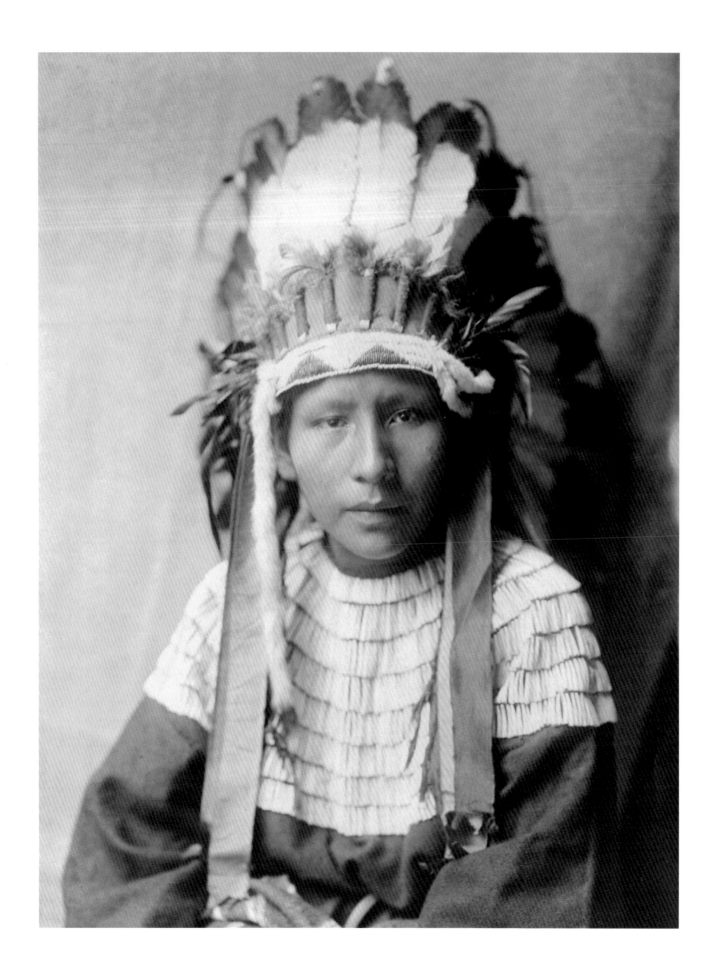

EDWARD S. CURTIS. *Noatak Child.* Gelatin silver print. Alaska, circa 1929.

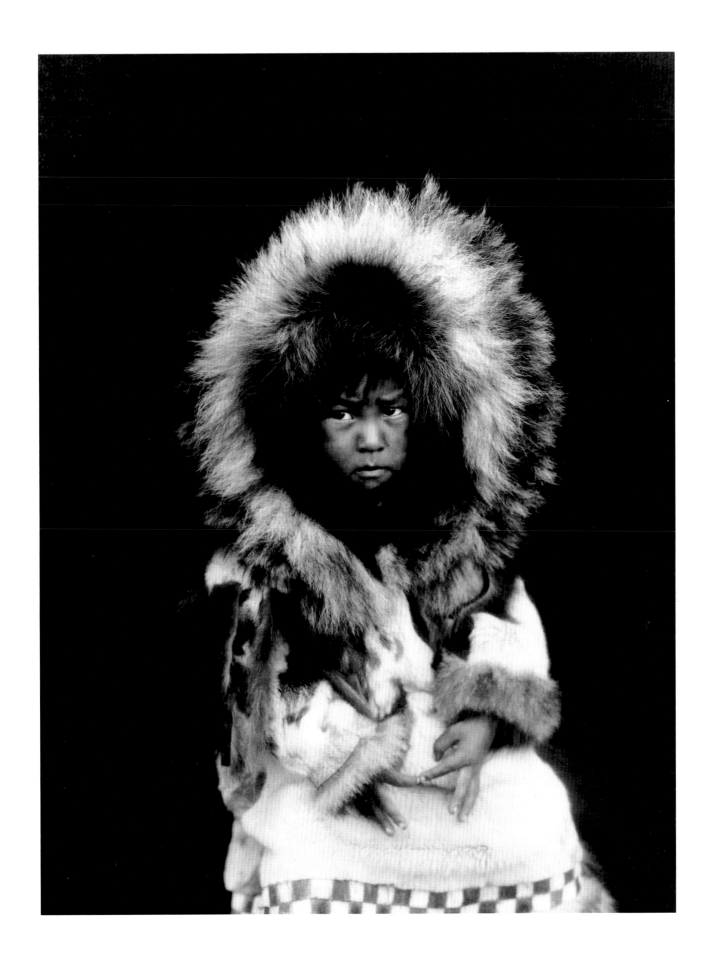

EDWARD S. CURTIS. *Tlakluit Child.* Gelatin silver print. Circa 1910.

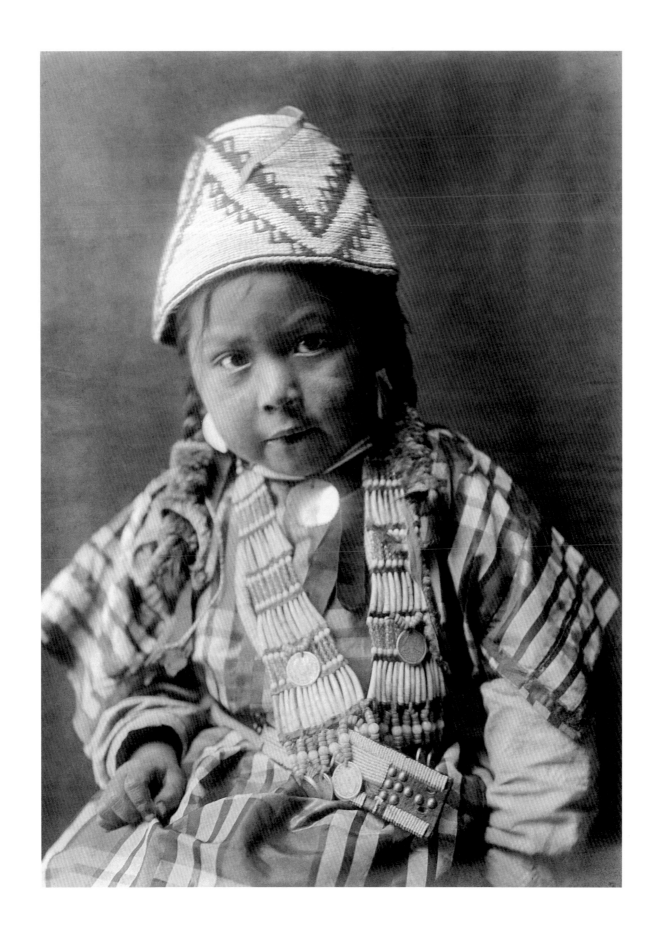

PHOTOGRAPHER UNKNOWN. *Eskimo Child Leaning on Block of Wood.* Gelatin silver print. Alaska, 1905.

Yes, they can be solitary bearers of a given world's customs, as we have just noticed, but they can also link arms as sovereign members of this neighborhood, that nation. Alan Lomax's *Mexican Girls* from San Antonio together show their willingness and ability to take on and take in the world. One struts, the other stands sure, settled. They are very much on their side of that fence. So with the young ballerinas as they join into a bowing threesome before their teacher, and so with the youngsters who regard and wield their guns. American girls and Italian boys, children learning to tame their muscles, to control an instrument at once alluring and dangerous, and children engaging with a kind of world view or ideology—one aesthetic, the other political. Such photographs remind us that childhood is a time of social affiliation and instruction, presenting innumerable moments that turn into membership.

"I always remember my girl scout meetings," a twelve-year-old Boston girl once remarked, and then her reasons: "We're all friends, and we like wearing the uniforms, and we do these exercises, and you feel better and better, stronger and stronger, and it's like—well, you could say, one big family, and there's each of us, and we'll sing and we'll talk, and pretty soon it's all of us sounding off or listening (some doing the one thing, and some doing the other thing) or everyone doing the same thing." As we look at these pictures, we hearken back to that girl's evocation of solidarity as it can emerge, come together in several people and become a singular experience for an assembled group.

ALAN LOMAX. *Mexican Girls.* Gelatin silver print. San Antonio, Texas, 1934.

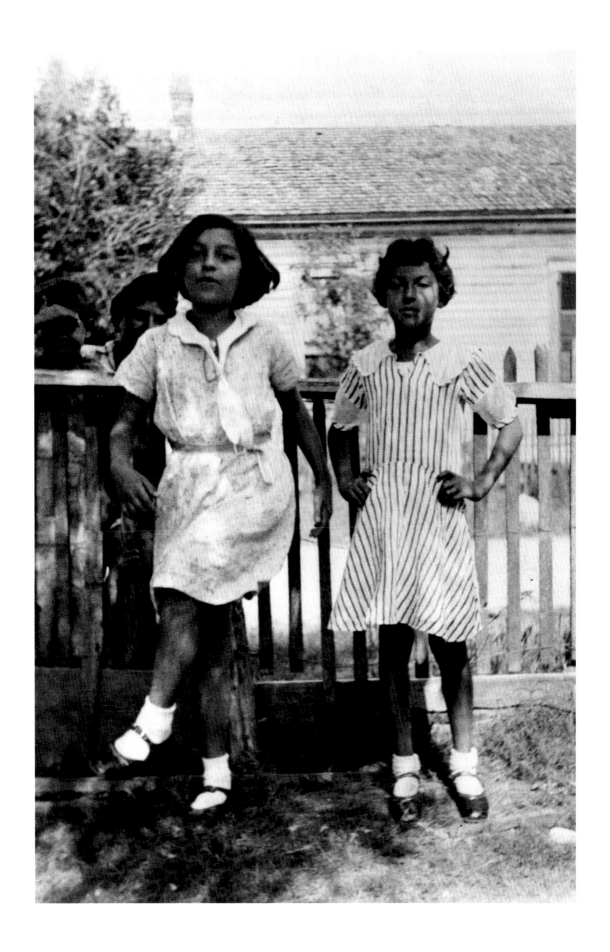

PHOTOGRAPHER UNKNOWN. *Ballet School for Baby Ballerinas.* Gelatin silver print. Madison, Wisconsin, 1955.

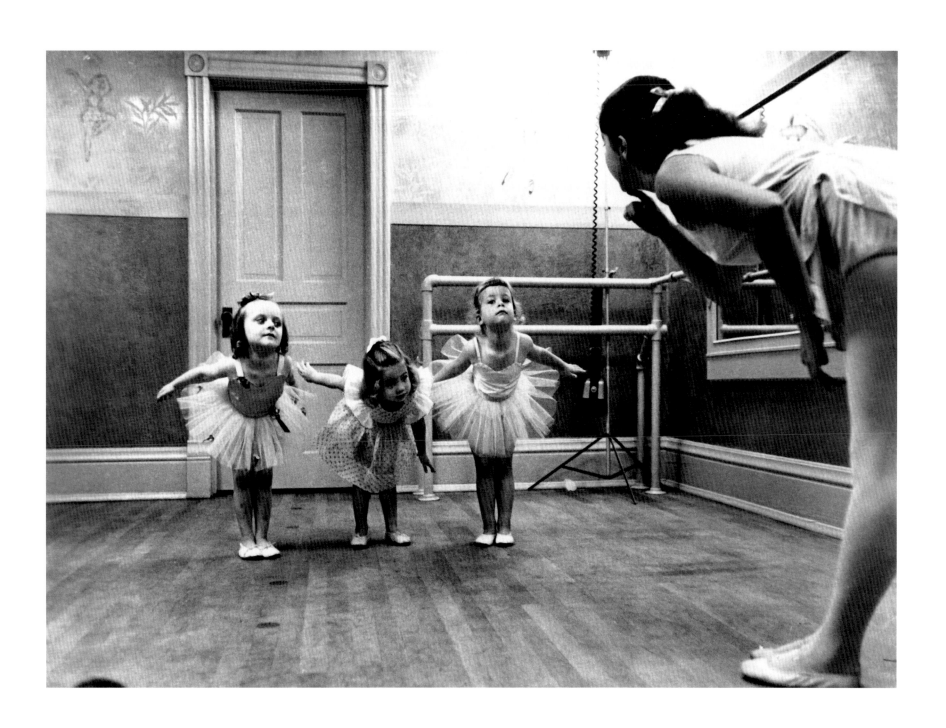

PHOTOGRAPHER UNKNOWN. *Youthful Members of the "Balillas" (Junior Fascisti)*. Gelatin silver print.
Rome, Italy, circa, 1930.

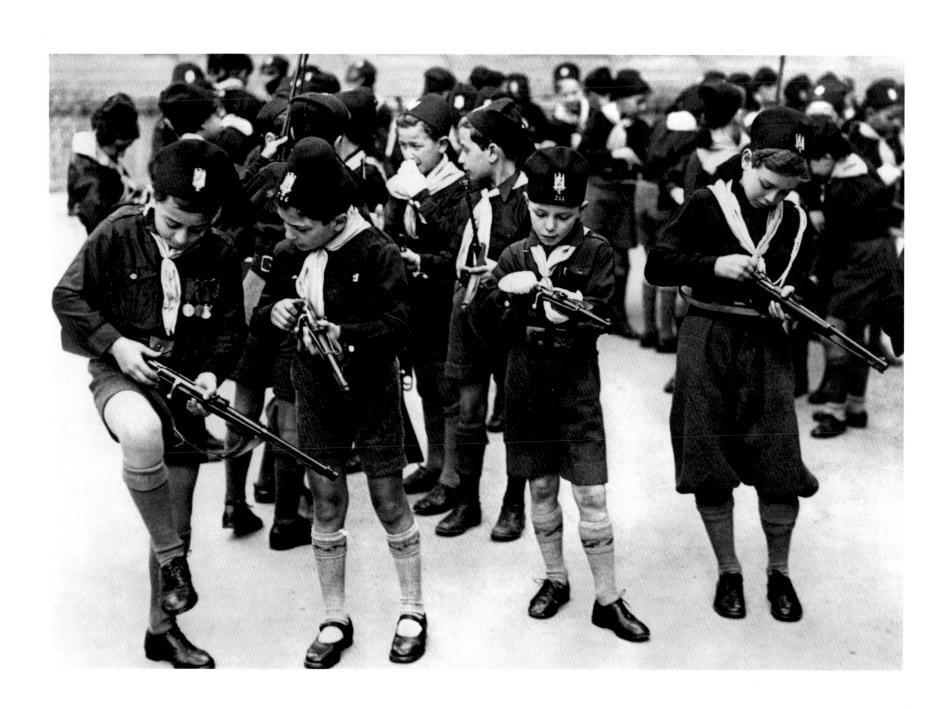

WHAT A GIRL SCOUT ONCE APPRECIATED, even extolled, a series of pictures (the blessedness of silent understanding enabled by pictures!) offers for our attention. Here are two boys peering intently. Two girls become, in a sense, one. The first holds the yarn, while the other one tests the needle, and as a duo, they complete their work. Here, too, are a pair of children smiling with a certain radiance that belies the word "slum" that the photographer, Jack Delano, supplies for our information. The girls are cavorting, we are entitled to think. Theirs is the sprightly frolic of youngsters able to have a lighthearted time of it, notwithstanding some of the gloom, if not doom, that the word "slum" prompts us viewers to consider as a background scene to the human one shining brightly before us.

RUSSELL LEE. *Two Boys.* Gelatin silver print. Donaldsonville, Louisiana, 1938.

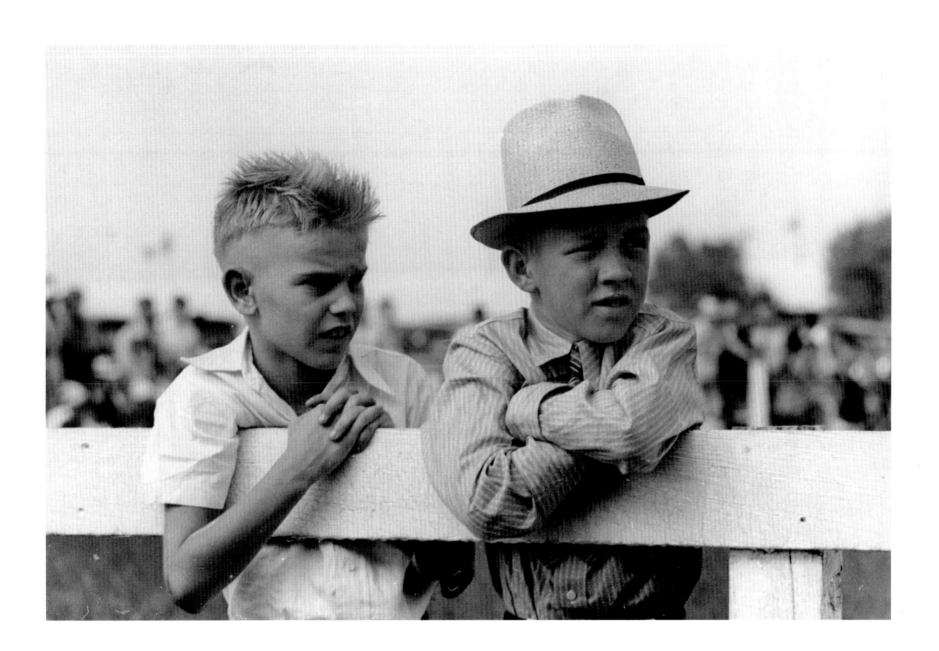

FLORENCE WARD. *Girls Playing with Yarn and Knitting Needle.* Gelatin silver print. Harlem, New York, between 1950 and 1970.

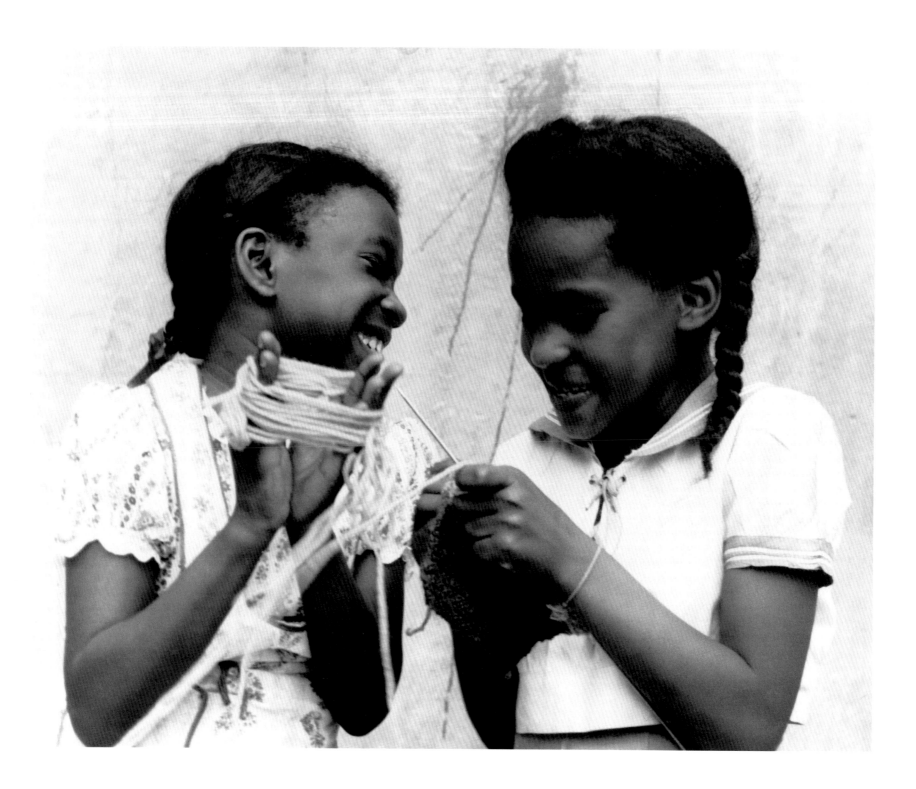

NATIONAL PHOTO COMPANY COLLECTION. *Two Children on Step*. Gelatin silver print. Between 1909 and 1932.

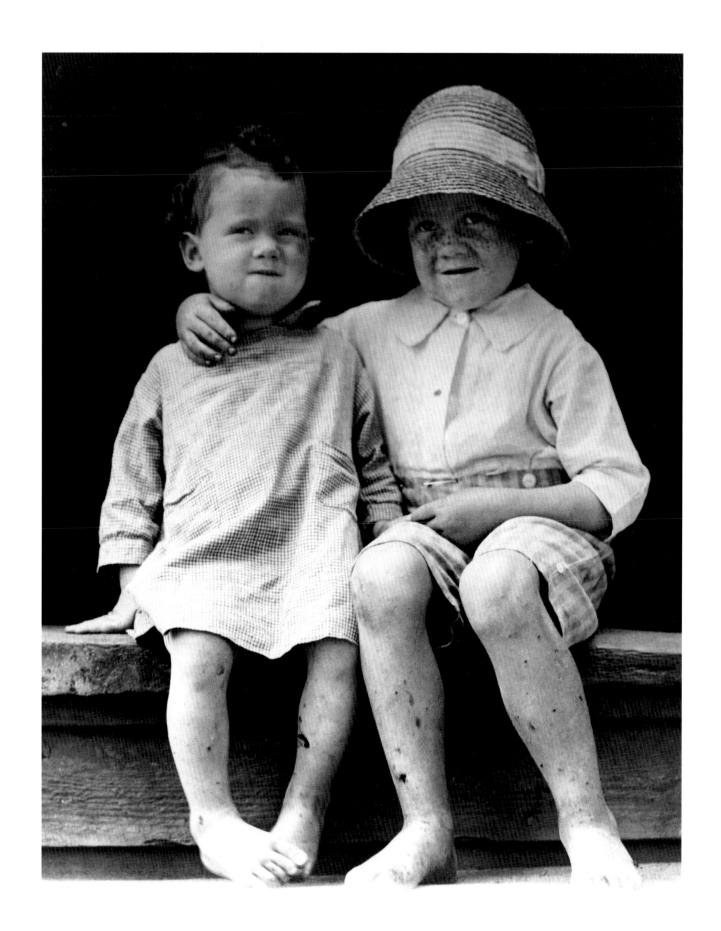

JACK DELANO. *Children in Slum.* Gelatin silver print. Utuado, Puerto Rico, 1942.

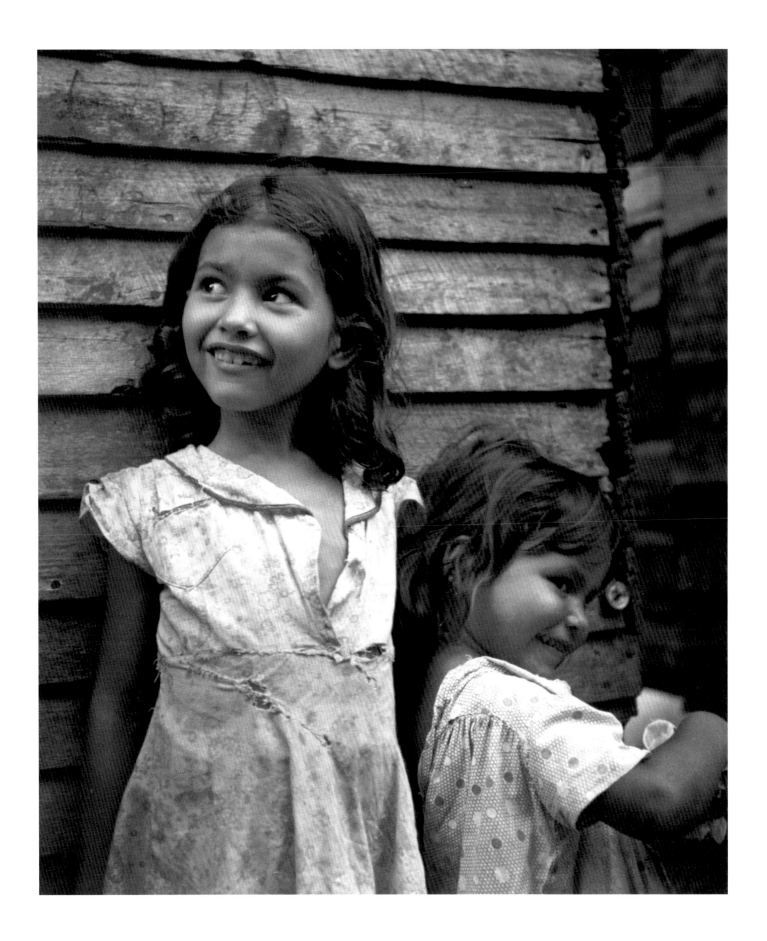

WE SHIFT BACK AND FORTH from our particular selves to six glimpses of children musing, observing, hailing, separately or near others. These are not formal, poised portraits, but rather poignant moments. A girl's face almost floats on its own, attached to no body in sight, her relaxed hair all that accompanies her in this sighting. A boy stands composed before his family, and its stove—our eyes meet his, catch his suspenders, wonder whether the photo on the wall is FDR, as our wartime president was often called during the year (1940) Jack Delano made this photograph. A girl sits with her kitten amidst the destruction wrought by a midwest tornado (the triumph of care over fear and sadness). Boys hold on to one another. A pea picker's child's wary gaze could be fear or apprehension, which seems hardly quelled by the comforting arm of her partially observed companion. A boy gives a holler—life expressing itself through affection shown, a call to others uttered.

JACK DELANO. *Daughter of a Farm Laborer.* Gelatin silver print. Caguas, Puerto Rico, 1941.

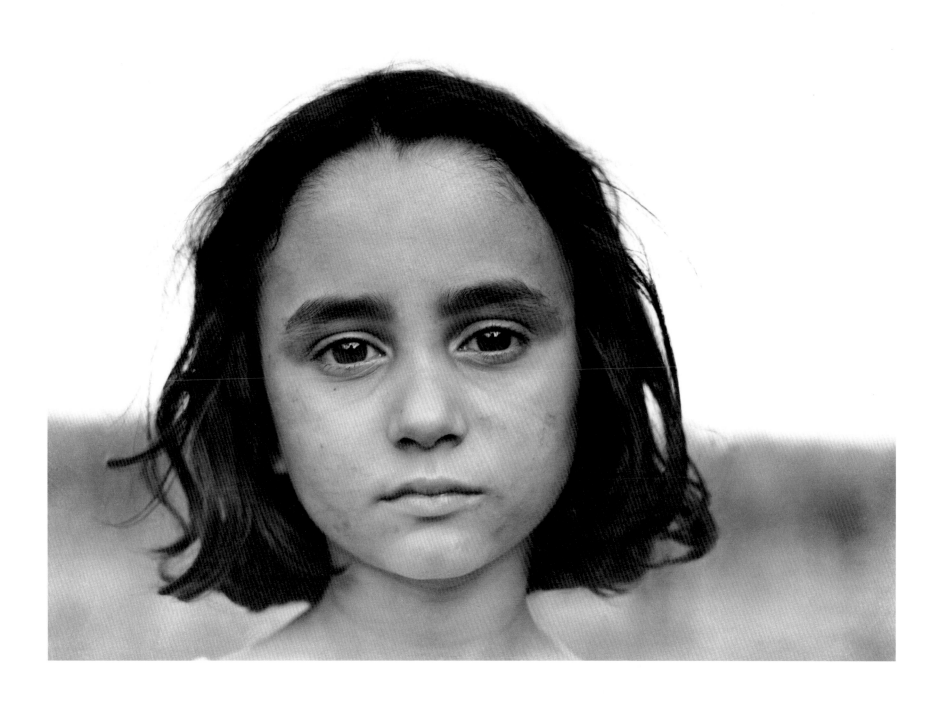

JACK DELANO. *The Family of Peter V. Andrews.* Gelatin silver print. Falmouth, Massachusetts, 1940.

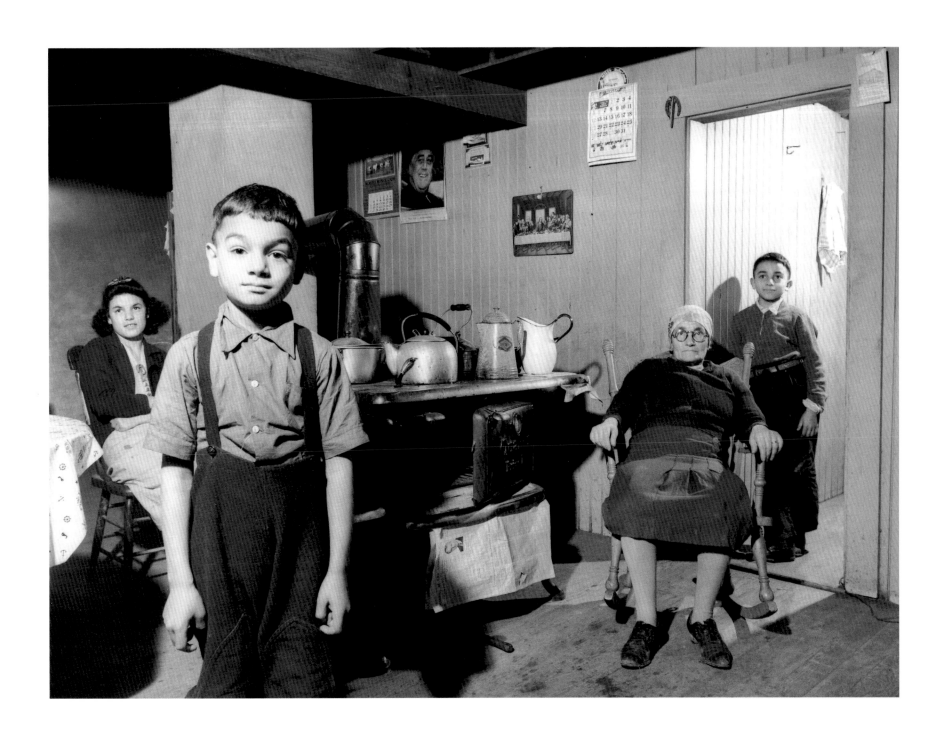

GREY VILLET. *Girl Soothing Her Kitten.* Gelatin silver print. Hickman Mills, Missouri, 1957.

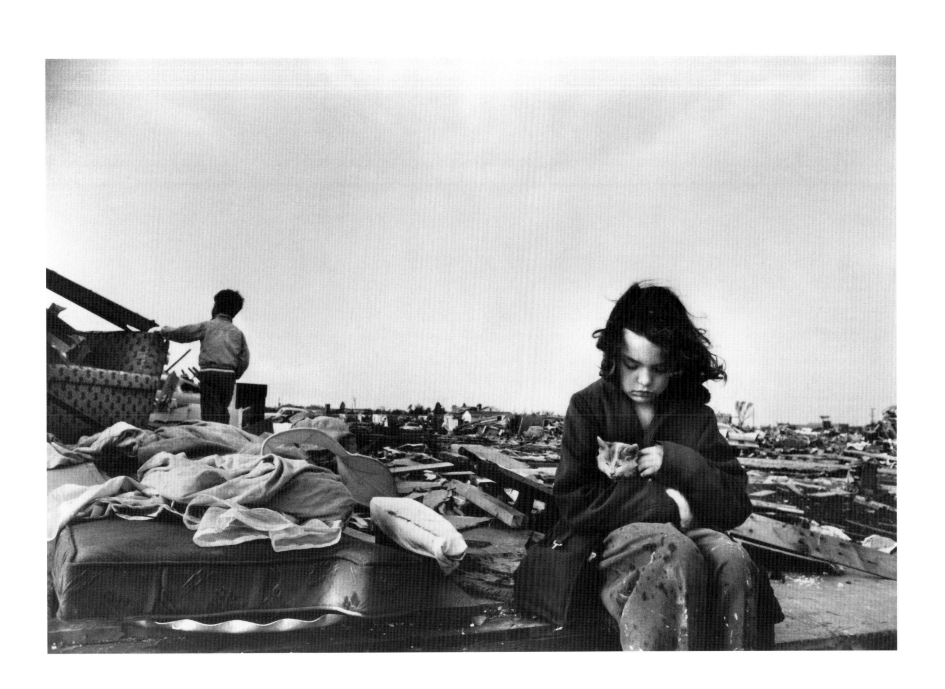

GORDON PARKS. *Children, Frederick Douglas Housing Project*. Gelatin silver print. Washington, D.C., 1942.

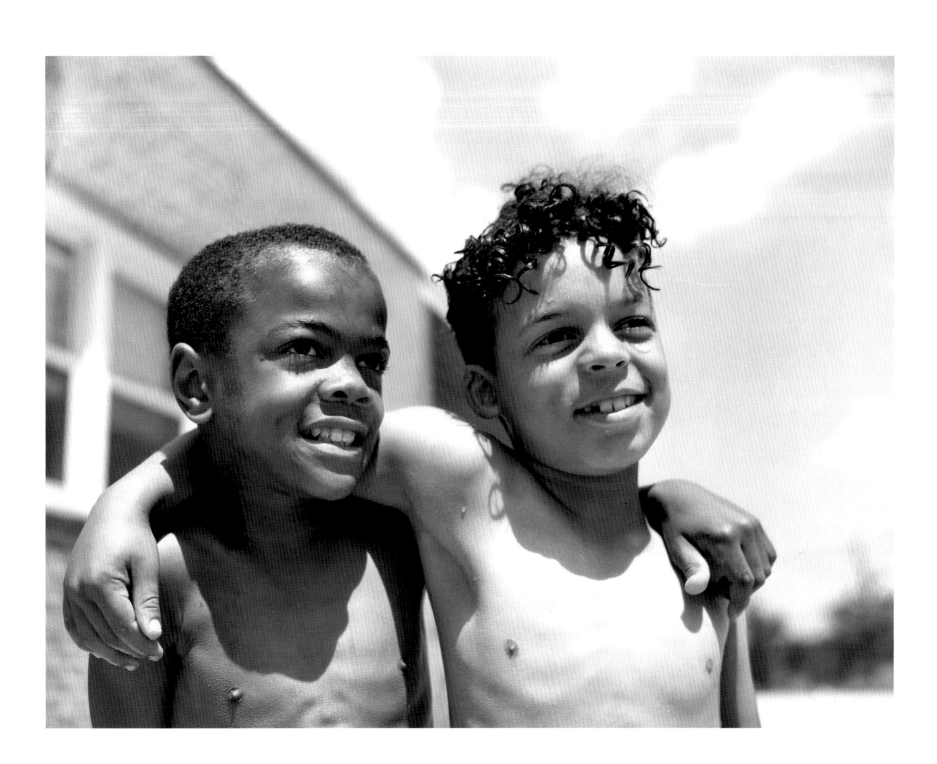

DOROTHEA LANGE. *Pea Picker's Child.* Gelatin silver print. Nipomo, California, 1935.

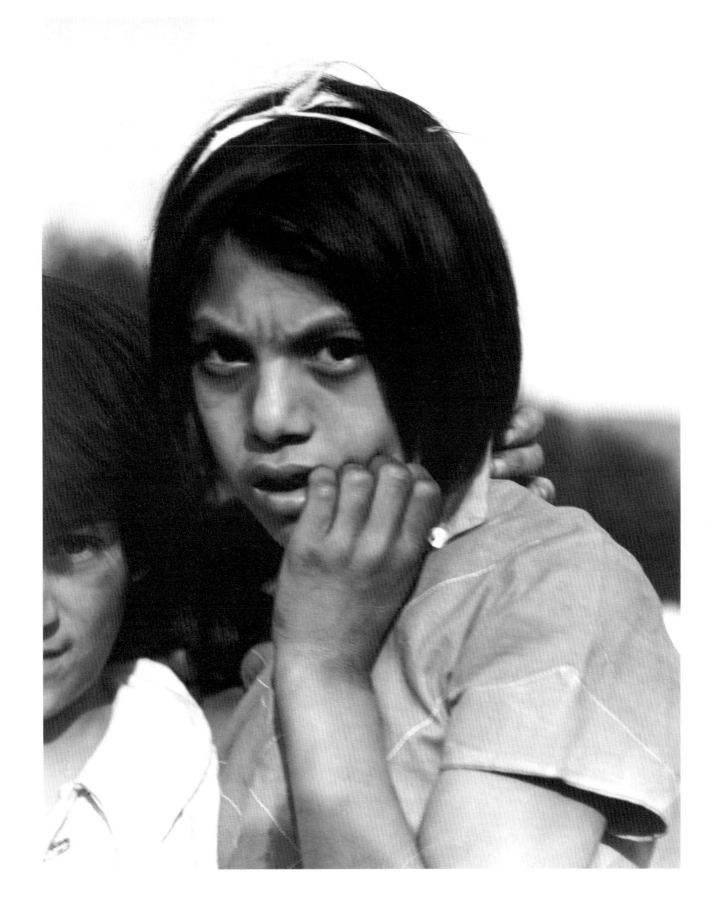

GORDON PARKS. *Boy at the Playground.* Gelatin silver print. Washington, D.C., 1942.

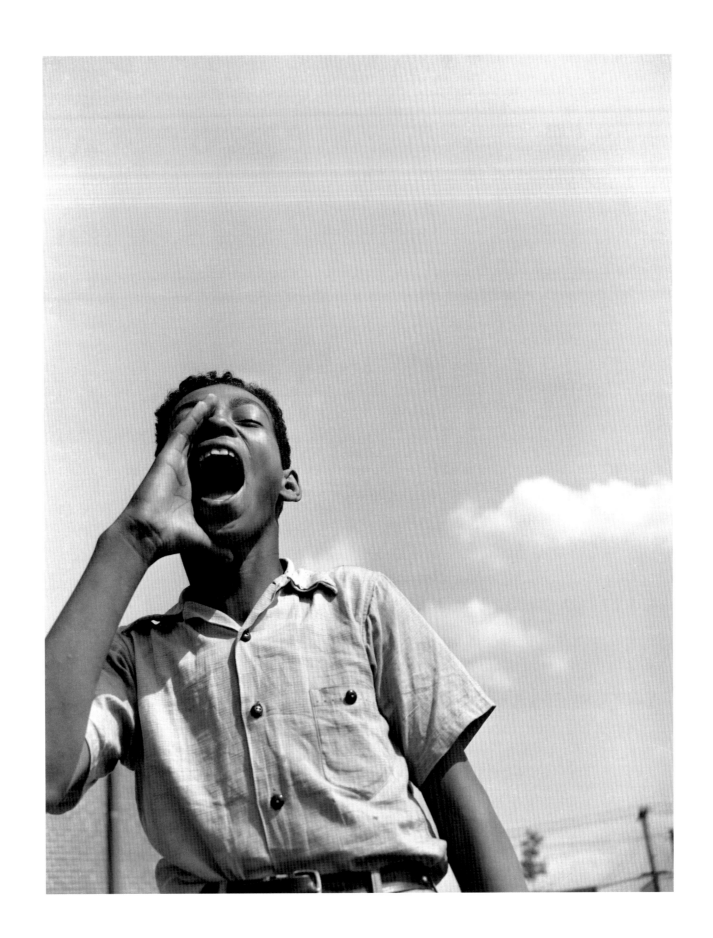

that give us much to consider about girls growing up. In the first, a girl holds onto her blouse with her right hand, sometime in the late nineteenth or early twentieth century—her hair disheveled, her lips ever so lightly parted, her eyes directly ready to meet ours. Following that white girl is an African American girl, her profile stately, her braids revealing evidence of the personal attention they have been given. Two more pictures both offer us two girls—girls conversing or girls jointly reading—and we are tempted to see, in both cases, the whole that can become the sum of its parts. The unaffected and sweet intimacy that these two sets of girls demonstrate, results in the appealing glow of these pictures. They seem to say "trust unselfconsciously given life," a moral example for us over a half century later.

The next three photographs show us children in unison. Two girls and a boy possess bicycles that show an emerging possible mobility for many. We learn that one dresses up for such an occasion. *Ring Toss,* which Clarence White documented in the last year of the nineteenth century, again reveals the formality of a kind of play and the delicacy of motion caught. And way over to Asia, we find three girls, seated, wide-eyed and addressing us with an unassuming directness, their hands ever so gently touching one another. Here is a growing grace of appearance and accompaniment, a natural and unpretentious composure that reminds us how much we all have to learn from others. The parents of those girls, one begins to realize, were able to teach their daughters how to get along amicably without the help of all those books (how to do this or that), which we in contemporary America seem to require constantly, urgently.

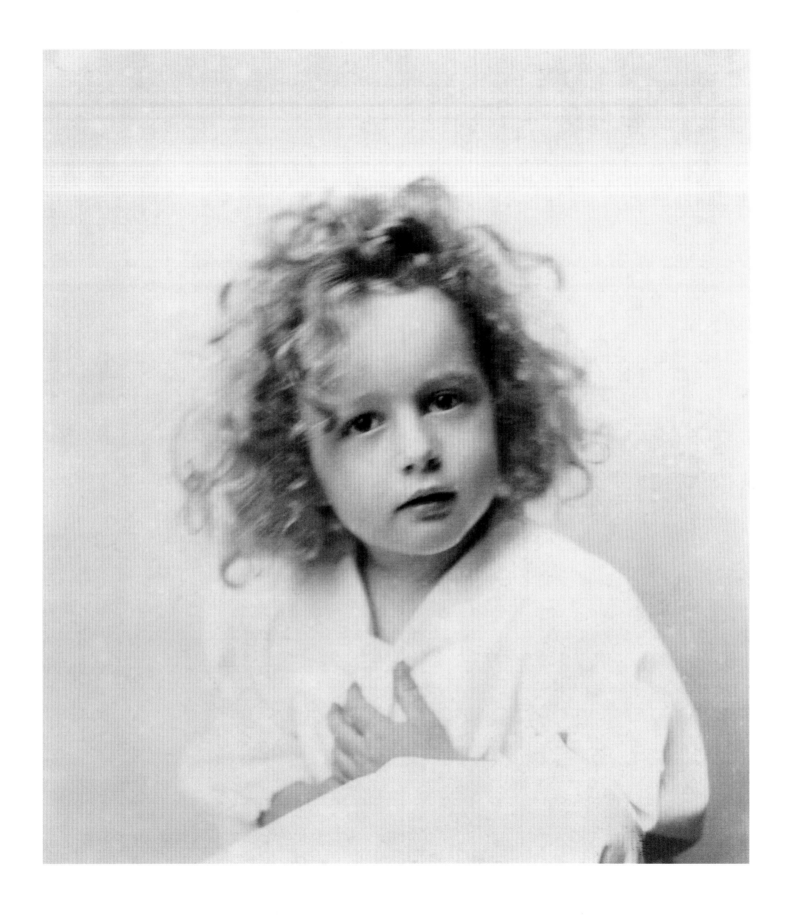

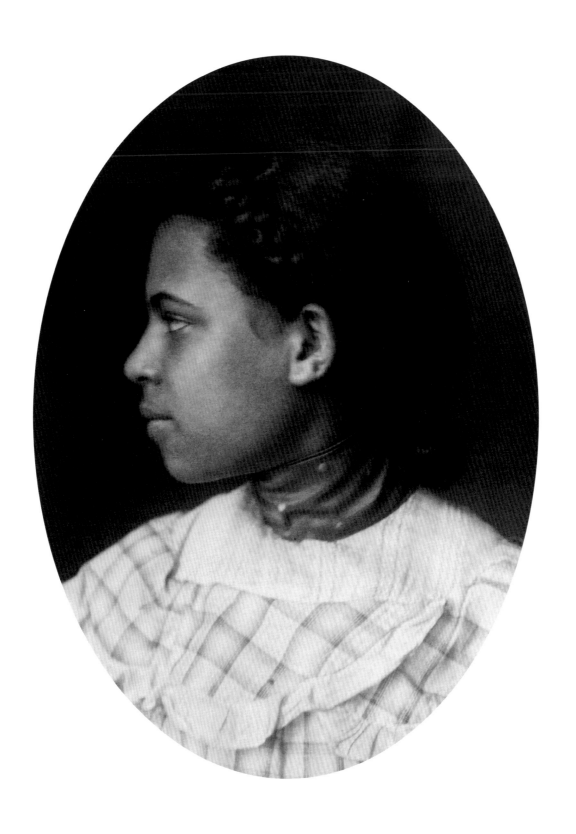

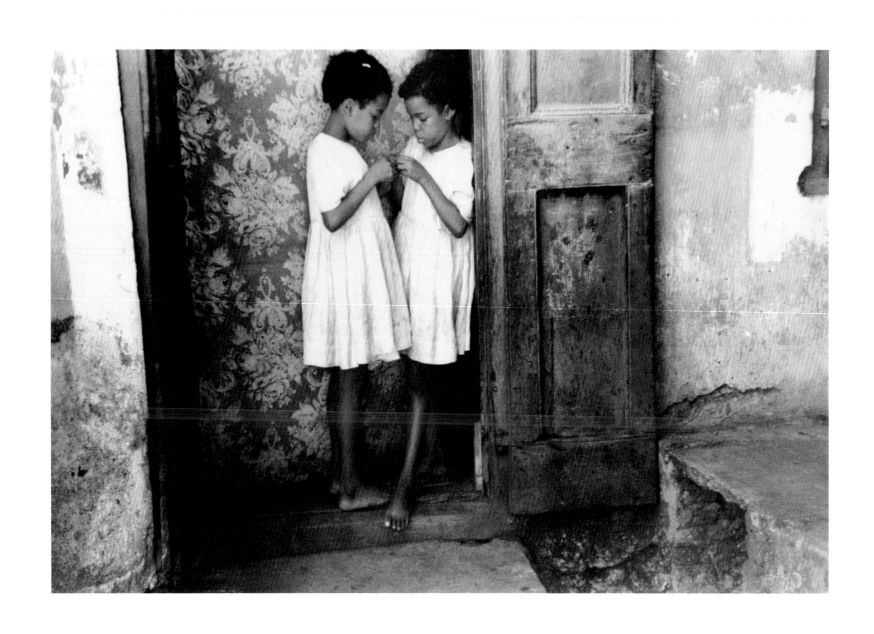

JACK DELANO. *Girls in Doorway.* Gelatin silver print. Charlotte Amalie, St. Thomas, 1941.

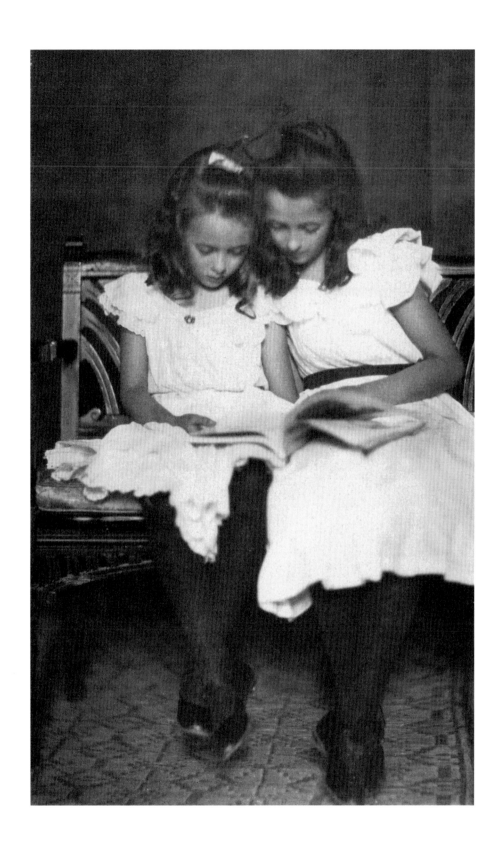

VIRGINIA PRALL. *Two Girls Reading*. Gelatin silver print. Circa 1900.

DETROIT PUBLISHING COMPANY. *Children with Bicycles and Tricycles.* Gelatin silver print. Between 1910 and 1920.

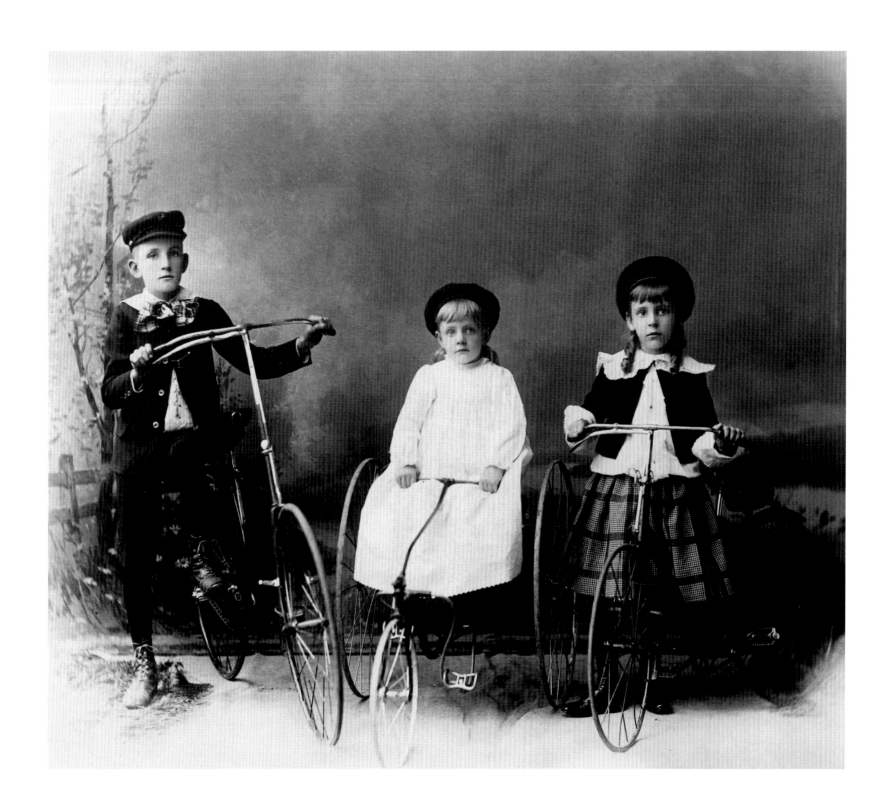

CLARENCE H. WHITE. *The Ring Toss*. Platinum print. Newark, Ohio, 1899.

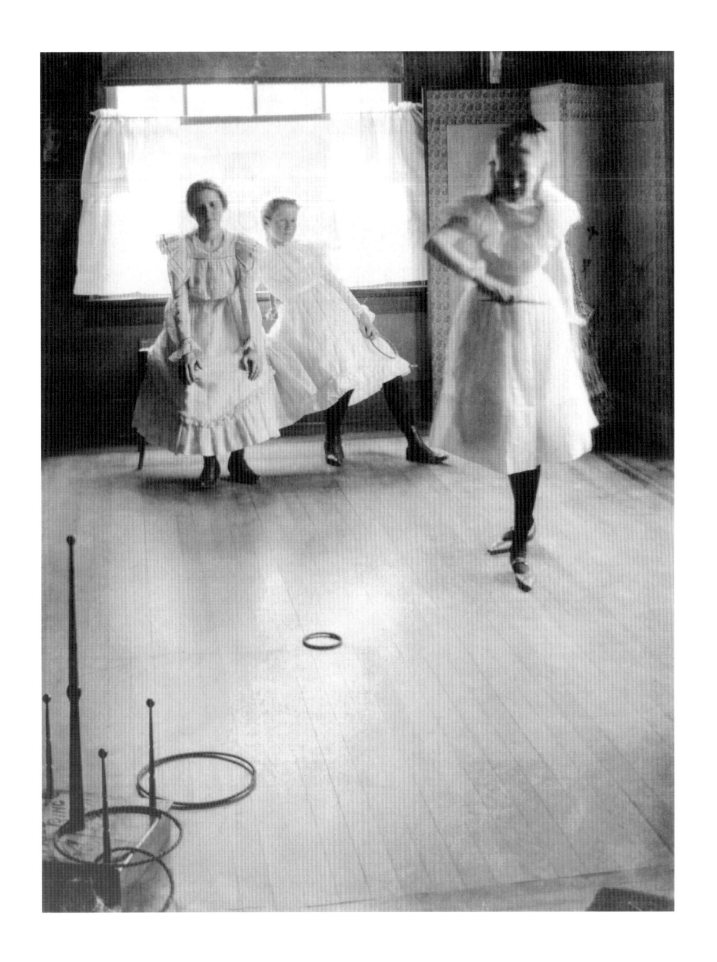

KEYSTONE VIEW COMPANY. *Singhalese Girls.* Stereograph. Ceylon, circa 1905.

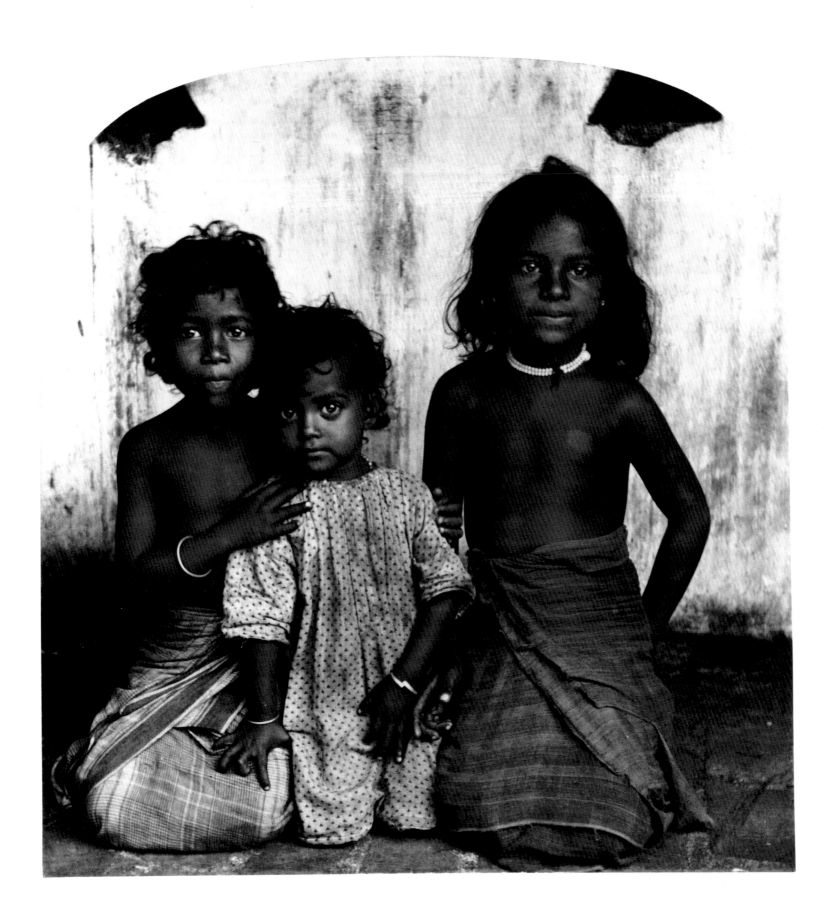

WE TAKE A BREAK NOW from the steady procession of young ladies. There is a threesome of boys for us to meet. These African American youths were seen together around 1900. We sense the unaffected nonchalance of two boys sitting, of one standing, their casual hats worn like crowns, their faces both impassive and appealing. They show us no hint of fear or the ingratiation that it can prompt in their very own young persons.

W.E.B. DU BOIS COLLECTION. *Three African American Boys*. Gelatin silver print. 1899 or 1900.

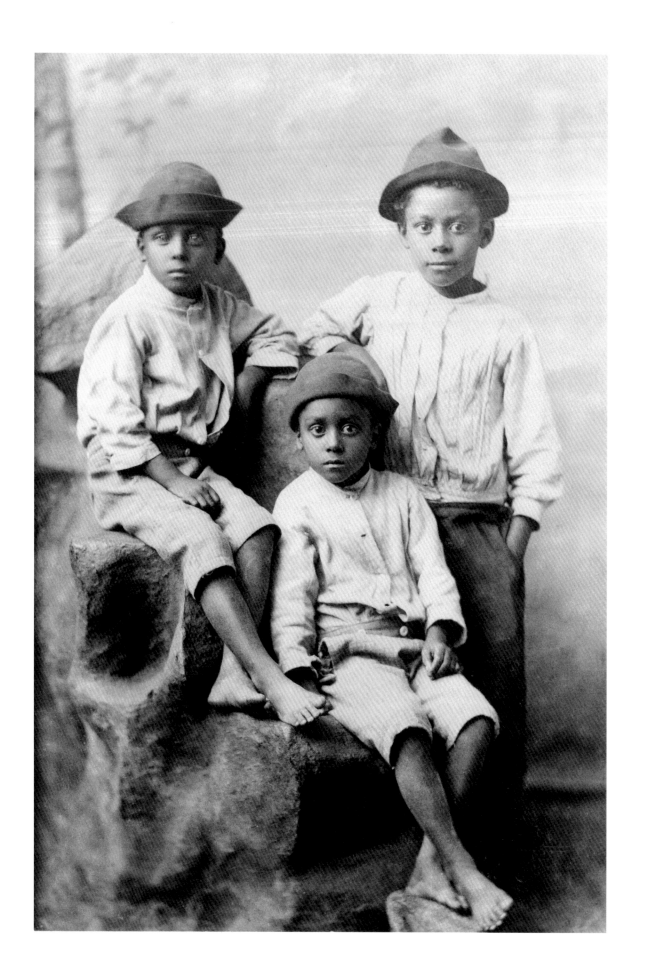

BACK, THEN, TO WOMEN, to Arnold Genthe's *Rosenberg Girl*. The alert dignity of her eyes joins her soulfulness. Some of us viewers will surely imagine her later on, as a woman of knowing connection to the world's events, with their meaning to her and impact on others.

The *Five Amish Children* Aubrey Bodine saw in 1953—one looking forward, two looking at us, and one whose eyes are lifted beyond—have a different connection. One imagines the spirit of the latter girl moving toward the God whose deeds and words have so informed the prayerful attention of the community to which these children belong.

ARNOLD GENTHE. *Rosenberg Girl.* Gelatin silver print. 1929.

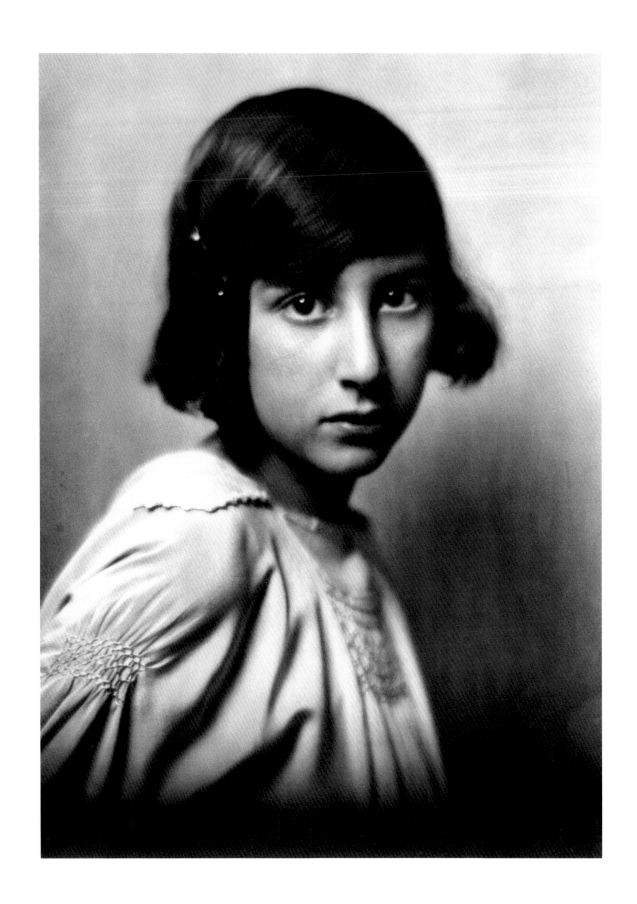

Five Amish Children. Gelatin silver print. Circa 1953.

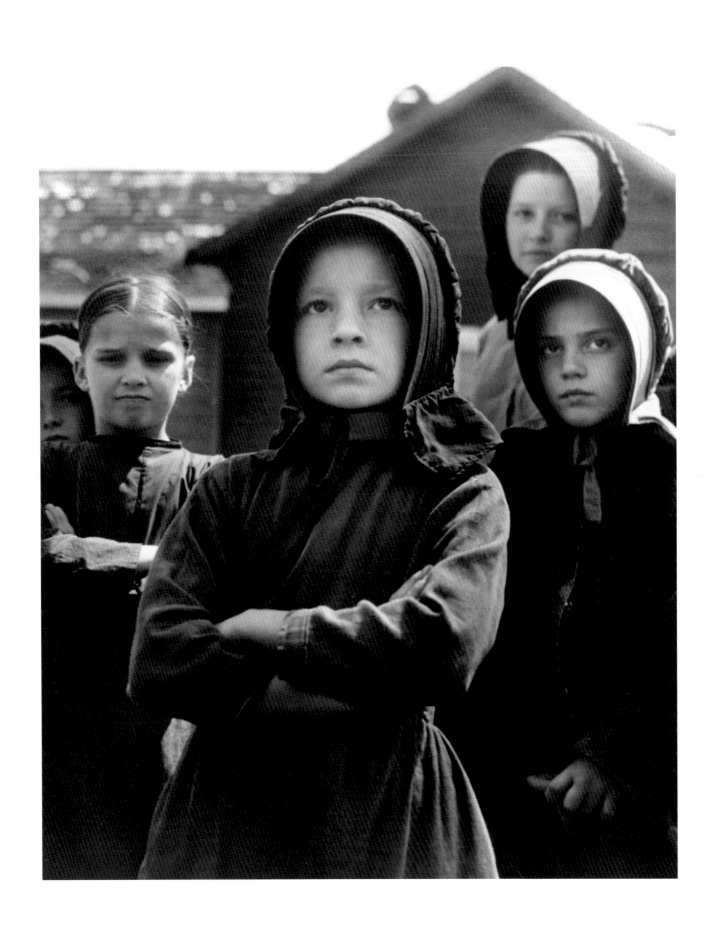

JACK DELANO. *Children at the Peter's Rest Elementary School.* Gelatin silver print. Christiansted, Saint Croix Island, Virgin Islands, 1941.

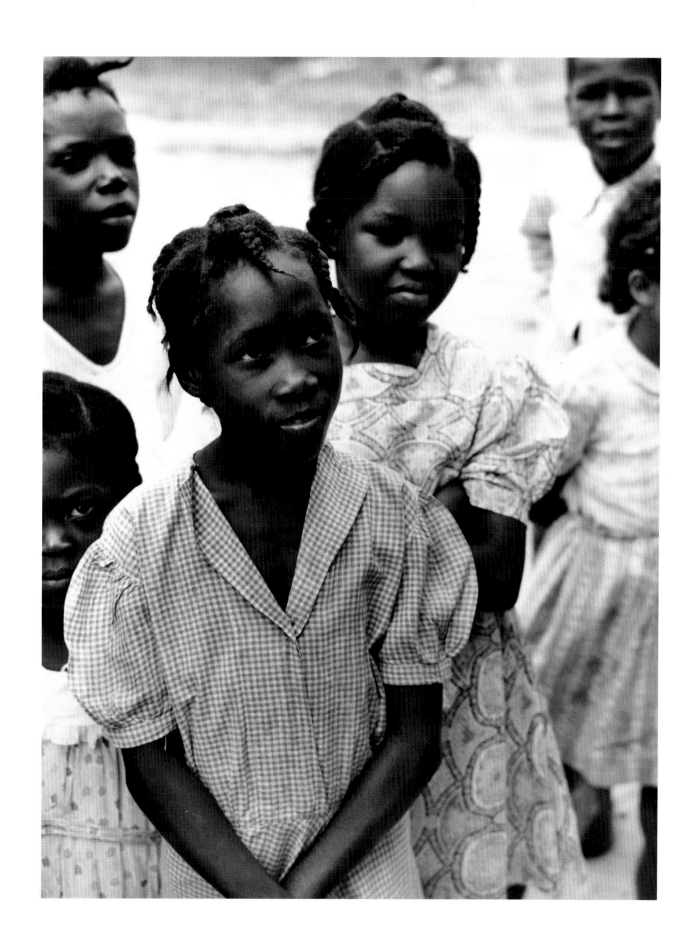

of course, children can also look at the world with wonder and careful interest, with a loyal attention that tells of affection received or hurt anticipated and bodily need felt, with patient pleasure at the world's attention or a humble willingness to present themselves to others. The Italian child who ponders the Houston newspaper from faraway America reminds us that even in the third decade of this past century, before the arrival of transcontinental commercial air travel and readily accessible radios, not to mention television sets all over in schools and homes, the young, like their elders, could cross continents, oceans, to be in touch with others with whom they chanced to share time and a planet's space.

Indeed, as we come to this archive's end, conclude our time spent, through the camera's magic, with individuals when once they were young, we are left to consider the fate of a daughter of a poor tenant farmer, of Jewish children in a crowded street of Warsaw, Poland, a few decades before the murderous horror of Hitler's army; and to consider also, English children looking upward to skies filled with warplanes. Finally, a thankful ode of sorts is given to us—a child's raking of the leaves (of time and experience).

All those fellow children of these past many decades, all those children these pictures show parading, seeing, posing, even sometimes peering, all those children the world over trying their hardest to get through the riddles of life, its variousness, its spells of good or bad. One hopes and prays for every one of them, for what their lives ended up being, and too, for all of us who contemplate their sight, their already apparent destiny, no matter their relatively few years.

A Newspaper That Traveled. Gelatin silver print. Udine, Italy, circa 1921.

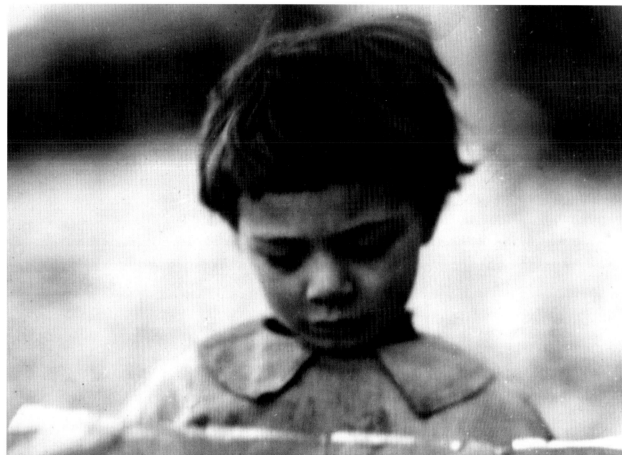

THE HOUSTON POST.

STORM IS STILL HIDING IN GULF

DOROTHEA LANGE. *Child of a Former Tenant Farmer*. Gelatin silver print. Ellis County, Texas, 1937.

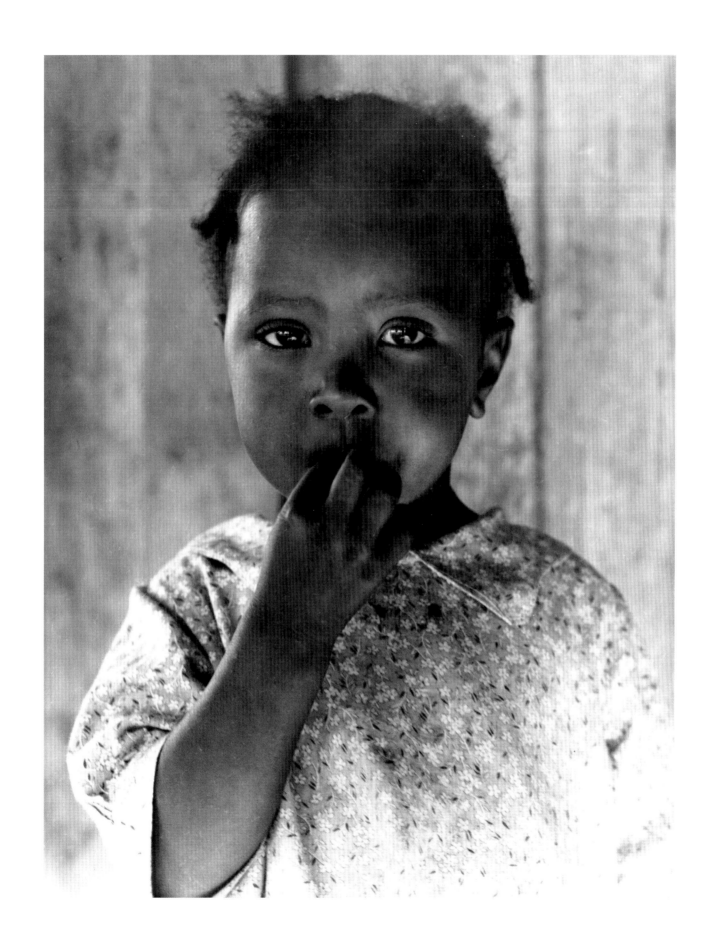

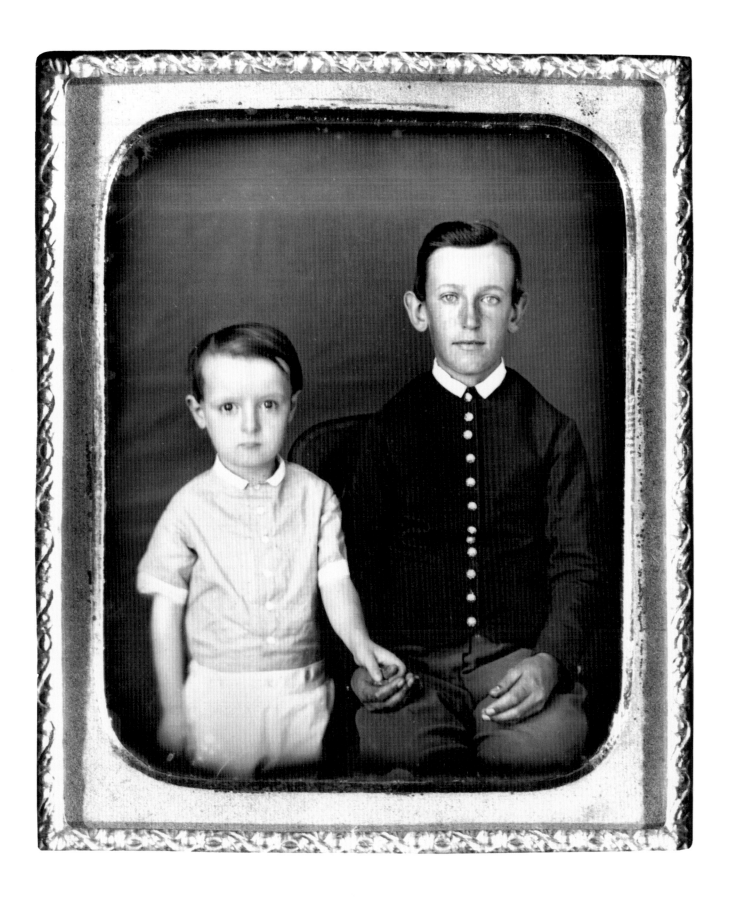

RUSSELL LEE. *Getting Ready for the Parade at the Fiesta of the Holy Ghost.* Gelatin silver print. Santa Clara, California, 1942.

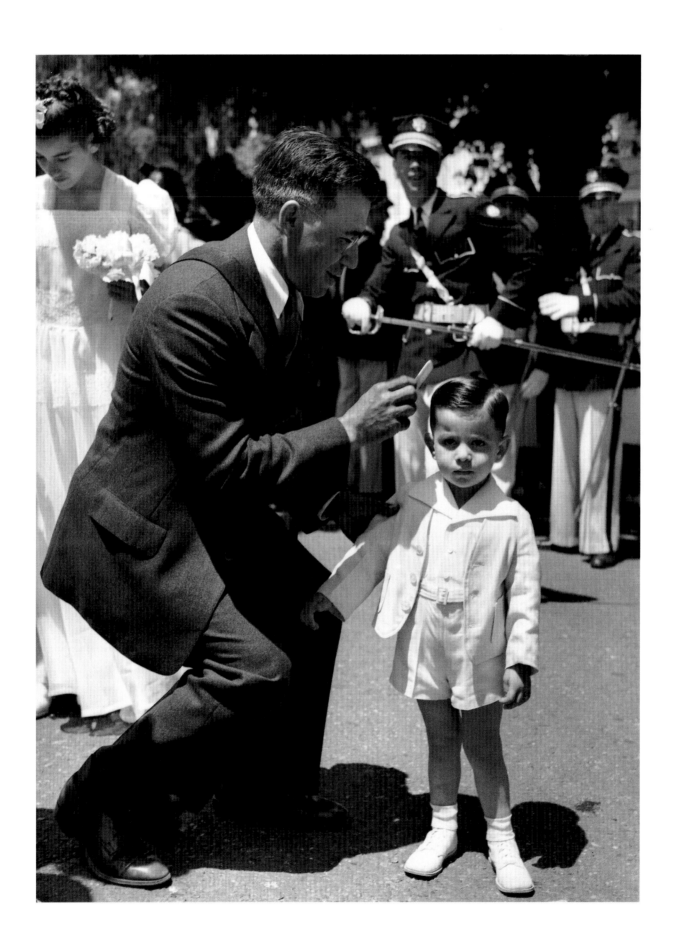

B. W. KILBURN. *Jewish Children in a Street.* Stereograph. Warsaw, Poland, circa 1897.

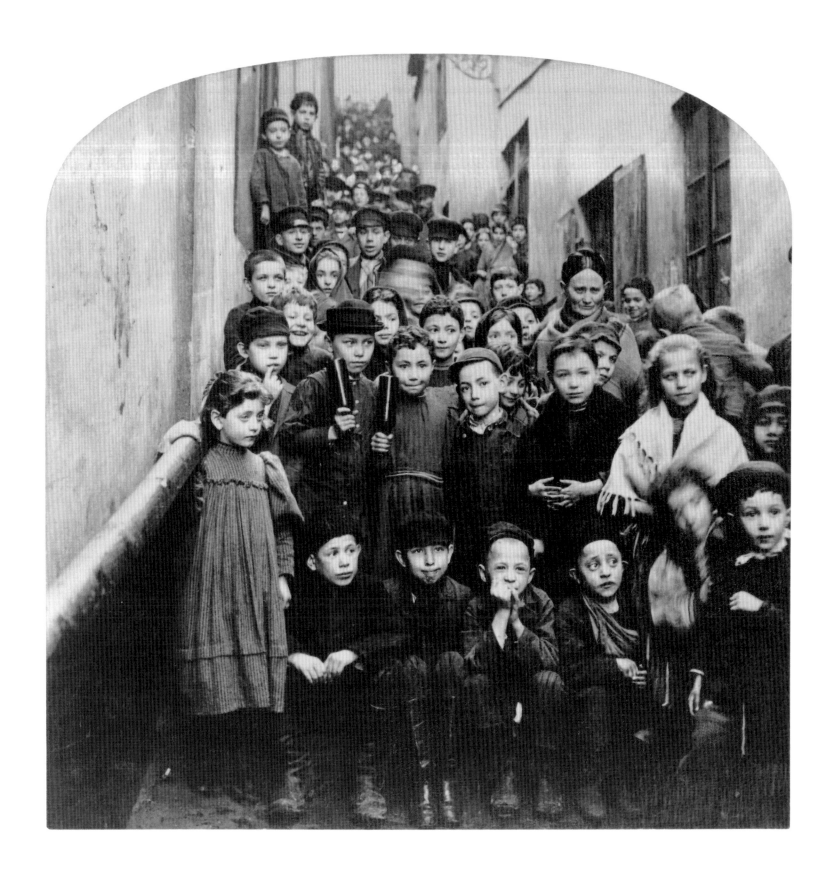

Children Taking Shelter During a German Air Raid. Gelatin silver print. England, 1940.

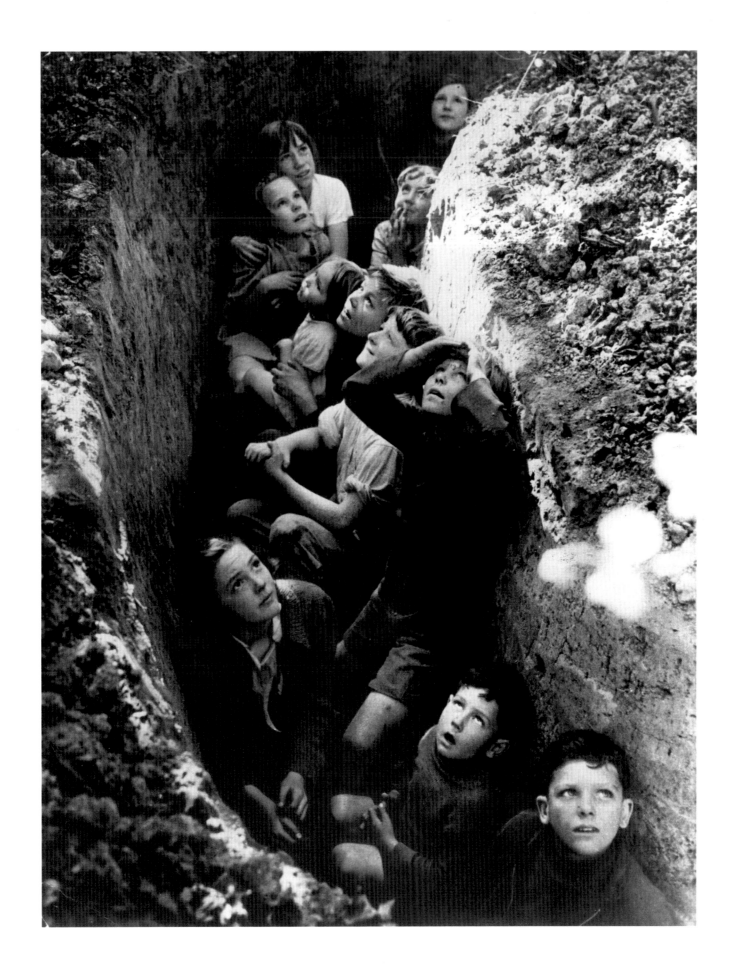

SAMUEL H. GOTTSCHO. *Three Children in Lower Manhattan.* Gelatin silver print. New York, 1914.

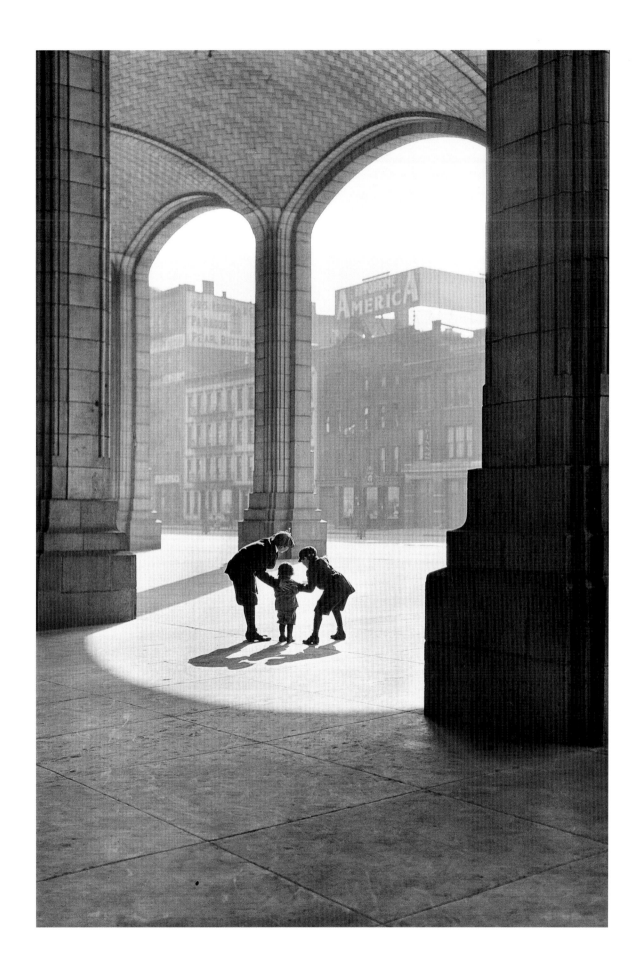

TONI FRISSELL. *Girl Raking Leaves.* Gelatin silver print. Circa 1950–1960.

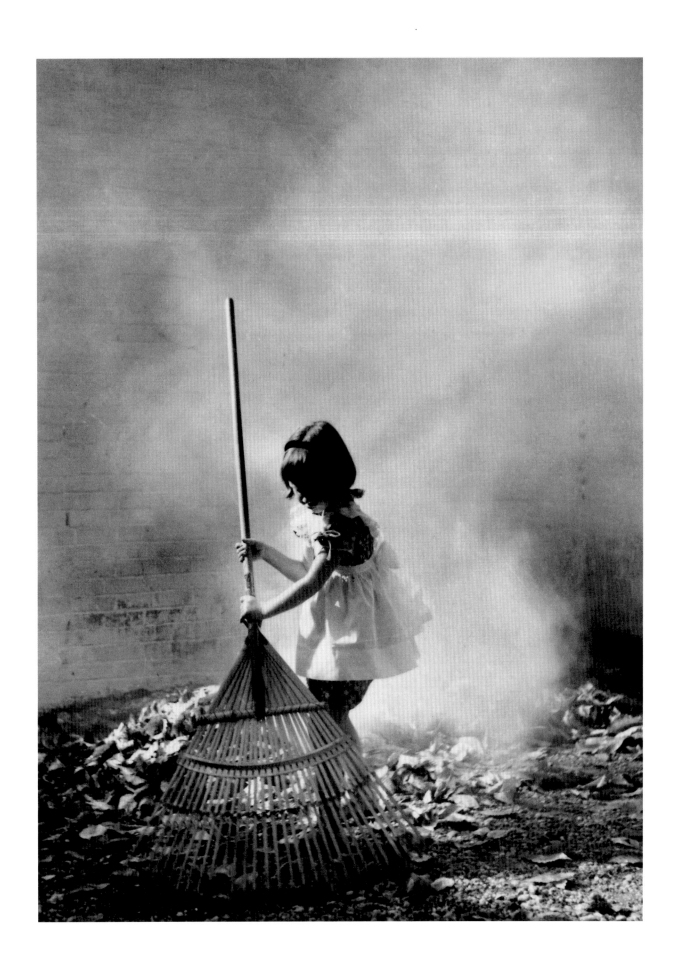

REPRODUCTION NUMBERS

The following list provides the reproduction numbers for the Library of Congress items in this publication where such numbers are available. Prints or transparencies may be ordered directly from the Library's Photoduplication Service, Washington, D.C., 20540-5230 (telephone 202-707-5640). The Library's general telephone number is 202-707-5000. Its Internet address is http://www.loc.gov.

THIS BOOK HAS BEEN PRODUCED

by Kales Press and the Library of Congress. It has been typeset in Granjon, a twentieth century adaptation of Garamond and Diotima, a typeface designed by Gudrun Zapf-Von Hesse in the 1950s. The book is designed by Linda McKnight and printed by Amilcare Pizzi, Milan, Italy. The images are tritones, printed on Phoenix Xantur Motion paper.

Page 15: LC-USZ6-2008
Page 17: LC-USZ62-9651
Page 19: LC-USF34-061044
Page 21: LC-USZ62-90521
Page 23: LC-USZ62-83911
Page 25: LC-USZ62-78714
Page 27: LC-USF33-004120-M1
Page 29: LC-USF33-001862-M2
Page 31: LC-USF34-054160
Page 33: LC-USZ6-1984
Page 35: LC-USZ62-103125
Page 36: LC-USZ62-13677
Page 37: LC-USZ62-104560
Page 39: LC-USF34-054005-D
Page 41: LC-H822-T-1689-002
Page 43: LC-USZ62-103028
Page 45: PLC-USF33-021312-M5
Page 47: LC-USF33-5146-M1
Page 49: LC-L9-68-3649-I, frame 16
Page 51: LC-USZ62-115259
Page 53: LC-USZ62-95978
Page 55: LC-USZ62-102399 (copyright © Aaron Siskind Foundation)
Page 57: LC-USF-3301-13082-M4
Page 59: LC-USZ62-101923
Page 61: LC-USF33-11318-M2
Page 63: LC-USZ62-90527
Page 65: LC-USZ62-10960
Page 67: LC-USZ62-119318
Page 69: LC-USZ62-93902
Page 70: LC-USZ62-120232
Page 71: LC-F9-02-5306-009-04
Page 73: LC-B8184-10573
Page 75: LC-USF33-13103-M5
Page 77: LC-USZ6-631
Page 81: LC-F9-04-5904-006-01a
Page 83: LC-USZ62-130896

Page 86: LC-USZ62-117291
Page 87: LC-USF34-48775-D
Page 89: LC-H824-T-1524
Page 91: LC-USZ62-112272
Page 93: LC-USZ62-107281
Page 95: LC-USZ62-105382
Page 97: LC-USZ62-130985
Page 99: LC-USZ62-71615
Page 105: LC-USF33-011787-M2
Page 107: LC-USZ62-122105
Page 109: LC-USZ62-106966
Page 111: LC-USF34-48097-E
Page 113: LC-USF34-048743-D
Page 115: LC-USF34-042905-D
Page 117: LC-USZ62-114377
Page 119: LC-USF34-013369-C
Page 121: LC-USZ62-118706
Page 123: LC-USF34-013372-C
Page 125: LC-USZ62-119389
Page 127: LC-USZ62-121107
Page 128: LC-USF33-021347-M1
Page 129: LC-USZ62-91950
Page 131: LC-D412-401
Page 133: LC-USZ62-41661
Page 135: LC-USZ62-103631
Page 137: LC-USZ62-69906
Page 139: LC-G401-3498-006
Page 141: LC-USZ62-99492
Page 143: LC-USF34-047082-D
Page 145: LC-USZ62-90817
Page 147: LC-USF34-017102-C
Page 149: LC-USZ6-1950
Page 151: LC-USW3-4576-D
Page 153: LC-USZ62-98872
Page 155: LC-USZ62-93161
Page 157: LC-G622-81586